BASEBALL IN DALLAS

CHRISTMAS, 2010

To Red;
My favorite Baseball player
& my favorite story teller....?
Would you believe....?

Your friend
Jerry Adami

RED —
I've really enjoyed all the time
we've spent together. Thanks
for all your wonderful stories.
— Matthew

BASEBALL IN DALLAS

5/15/15

Chris Holaday and Mark Presswood

ARCADIA

Published by Arcadia Publishing,
an imprint of Tempus Publishing, Inc.
Charleston SC, Chicago, Portsmouth NH,
San Francisco

Printed in Great Britain.

Library of Congress Catalog Card Number: Applied For.

For all general information contact Arcadia Publishing at:
Telephone 843-853-2070
Fax 843-853-0044
E-Mail sales@arcadiapublishing.com

For customer service and orders:
Toll-Free 1-888-313-2665

Visit us on the internet at http://www.arcadiapublishing.com

CONTENTS

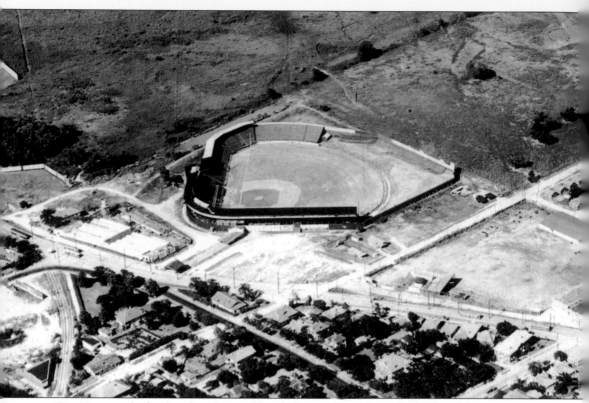

For 40 years, the home of professional baseball in Dallas was on the banks of the Trinity River in Oak Cliff. The ballpark, which went through three name changes (Steer Stadium, Rebel Stadium and Burnett Field), welcomed countless baseball fans from the mid-1920s through the mid-1960s.

INTRODUCTION

The city of Dallas has a rich history in the sport of baseball extending back to the 1870s when the professional game first found roots in Texas. In 1888, the Dallas Hams were a founding member (and first champion) of the professional Texas League. The relationship between the city and that league would last, off and on, through 1971 for a total of 76 seasons. The first half-century of professional baseball in the city saw some great (and not so great) teams take the field in a Dallas uniform. There were some last place finishes, but there were also several pennants won. With the major leagues far away to the north, players like Curley Maloney, Jewel Ens, Snipe Conley and Zeke Bonura were the heroes for countless local baseball fans.

During the twenties it was the western rival Fort Worth Panthers that owned the spotlight, winning six straight Texas League Championships from 1920 through 1925. But in 1926, Dallas broke the Panthers streak, winning their first championship since 1918 (sixth overall). The Steers would win two more championships during the Depression era behind the leadership of owners Tavener C. Lupton, Sol Dreyfuss, and George Schepps, and with the help of managers Happ Morse, Bobby Goff, and Al Vincent among many others.

In 1948, wealthy oilman Dick Burnett purchased the Dallas ball club. A great promoter of the game, Burnett helped his team flourish. He brought national recognition to the team by being the first to integrate the Texas League, in 1952, and he established a minor league attendance record by attracting more than 53,000 fans to the Cotton Bowl for Opening Day in 1950. For that game he paid a team of legendary players including Ty Cobb and Tris Speaker to suit up in a Dallas uniform. Burnett was also one of the first to believe Dallas was a good site for a major league franchise and he worked toward that end.

The decade of the 1960s saw a merger of the team with Fort Worth and a move to a higher classification for a short time as all focused on bringing major league baseball to the Dallas-Fort Worth area. Both the American and National Leagues considered the Dallas area a possible site for a team, but both leagues passed on an expansion into the region. Finally, on September 20, 1971, Robert Short, owner of the Washington Senators, received approval to move his club to Arlington for the following season.

The major league era officially began in the Dallas-Fort Worth area on April 21, 1972, when the Texas Rangers, as the team was renamed, hosted the California Angels in front of 20,105 at Arlington Stadium. In the years since, several all-time baseball greats have worn a Rangers

uniform. The legendary Ted Williams managed the Rangers for their first season and Hall of Famers Gaylord Perry, Ferguson Jenkins and Nolan Ryan all pitched for the team. More recent players Rafael Palmeiro, Ivan Rodriguez, Juan Gonzalez and Alex Rodriguez may also end up enshrined at Cooperstown one day.

Minor league baseball is also being played in the Dallas area once again. In 2003, Rangers owner and now minor league owner Thomas Hicks moved the Shreveport Swamp Dragons to the city of Frisco, a northern Dallas suburb, to become the RoughRiders, the Texas League farm club of the Rangers.

This book is not intended to be an in-depth study of professional baseball in Dallas and the surrounding area. Instead we intend it to be a collection of photos and stories that capture the spirit of the game in the city. We also hope to share an important part of local history with which many may not be familiar. Those wishing more information on the history of baseball in Dallas, particularly the minor league years, should read William B. Ruggles' *The History of the Texas League of Professional Baseball Clubs, 1888–1951* (published by the Texas League) and *The Texas League, 1888–1987* (Eakin Press) by Bill O'Neal. *The Encyclopedia of Minor League Baseball* edited by Lloyd Johnson and Miles Wolff and published by *Baseball America*, was also immensely helpful and includes a wealth of information on baseball in the state of Texas.

While many of the photographs in this book came from our personal collections, we never could have completed this project without the help of others. We would like to thank Rachel Howell of the Dallas Public Library, outstanding photographers Tim Phillips and Andrew Woolley, collector John Esch, Rebecca King and Aaron Artman of the Frisco RoughRiders, and Rick Barrick of the *Dallas Morning News*. We would also like to thank Jeff Reutsche, our editor at Arcadia Publishing, for his patience and support.

ONE

Steers, Rebels, and the Early Years of Dallas Baseball

It is unknown when the game of baseball was first played in Dallas. There is record of a game between amateur teams from Dallas and neighboring Fort Worth taking place in 1877, but baseball in some form had probably been played for several years previous to that. Following the Civil War, the first truly professional baseball clubs were being organized in the North to provide entertainment for paying fans. Some of these teams traveled on barnstorming tours in which they would play local teams from the destination city, and eventually these exhibition games found their way to Texas. As the cities of Texas began to grow in the late 1800s, and baseball became more popular, it became more feasible financially for them to support their own professional teams. In December of 1887, a group met to organize the first professional league in the state. This new "Texas League" began play in 1888 and consisted of teams in Dallas, Austin, San Antonio, Galveston, Fort Worth, Houston and New Orleans. Leon Vendig was president of the Dallas franchise. The league struggled through the first season, and some clubs dropped out, but in the end Dallas was named champion of the league's inaugural season.

In its early years the Texas League experienced several stops and starts. For a couple of seasons it failed to operate at all, but when it did, a team from Dallas was involved. Dallas finished first in the regular season in 1895 and was leading the league in 1898 when it suspended play due to the Spanish-American War. The team also won a pennant in 1903 and tied for the league title in 1910.

One of the important figures in the early years of Dallas baseball was Joe Gardner. In 1903, he purchased the Dallas club with saloon owner Ernest Bohne (whom he bought out one year later) and operated it through the 1916 season. Gardner helped stabilize baseball in the state and even financed clubs in Greenville and Waco when teams were needed to round out the Texas League schedule. In 1916, another very significant figure in Dallas baseball entered the scene when pitcher James "Snipe" Conley joined the team. The popular spitballer spent 12 consecutive seasons in a Dallas uniform and helped the team win back-to-back pennants in 1917 and 1918. Conley led the league with 27 wins (including 19 in a row) and 171 strikeouts in 1917. He served as playing manager in 1926 and '27.

In 1922, a group of Dallas businessmen including J. Walter Morris and Ike Sablosky purchased the team and renamed it the Steers. The new ownership group saw baseball in Dallas

thrive, and in 1925 the Steers topped 200,000 in attendance for the first time. The next season the team drew even greater numbers as 286,806 passed through the turnstiles. Having a good team in 1926 certainly helped boost attendance. Guided by Snipe Conley, the Steers finished with an 89-66 record, $3^1/2$ games ahead of San Antonio, to take the pennant

The 1927 and '28 seasons were not successful ones (fifth and seventh place finishes, respectively) but in 1929 the Steers' fortunes changed. The team started off the season with a league-record Opening Day attendance of 15,333 and cruised to win the first half of the season. They then went on to defeat second half champ Wichita Falls in the playoff to take another pennant.

In 1930, future Hall of Fame pitcher Grover Cleveland Alexander made a brief appearance with the Steers. Alexander, who had won 373 big league games, was released in mid-season by the Philadelphia Phillies. He joined Dallas and pitched his final five games in the Texas League. It wasn't a successful end to his legendary career, however, and Alexander finished with a 1-2 record and an 8.25 ERA.

The Steers didn't contend for another pennant until 1932. That season they finished strong to win the second half, but were swept in the playoffs by Beaumont, a team that featured league MVP and future Hall of Famer Hank Greenberg.

In 1935, the Steers became a part of a major league farm system for the first time when they signed a working agreement with the Chicago White Sox. The following season, second baseman Les Mallon, the Texas League MVP, led Dallas to a first place finish, but the Steers lost to Tulsa in the playoffs. The 1936 season was also the first in which the Texas League All-Star Game was held. The event took place in Dallas at Steers Stadium, and over 9,000 fans turned out.

In 1938, George Schepps purchased a controlling interest in the team from his partners for $150,000. He took over the team presidency from Sol Dreyfuss, who had served in that capacity since 1931, and renamed the team the Rebels. George Schepps and his brother, Julius, who was part owner of the team, were important figures in Dallas business as well as baseball. Starting with a bakery their father owned, the two built a business empire that included insurance firms, banks, radio station KIXL and other interests in addition to the baseball team. Both went on to become prominent philanthropists in later years. George Schepps would also found the Texas Baseball Hall of Fame in 1978 and serve as chairman of its selection committee until his death in 1998.

In Schepps' first season in control, the Rebels just missed winning a pennant. In 1933, the league had begun using the Shaughnessy playoff system in which the top four finishers in the standings met in a playoff for the title. The 1939 Rebels finished second and won in the first round of the playoffs, but lost to arch-rival Fort Worth in the finals. In 1941, the Rebels could do no better than fourth place with an 80-74 record, but that was good enough for a berth in the post-season. They proceeded to defeat both first-place Houston and second-place Tulsa to take another pennant.

The Texas League suspended operations from 1943–1945 due to the war, but when it returned in 1946, Dallas, now a Detroit Tigers farm club, claimed the pennant. The Rebels, led by pitcher/outfielder Henry "Prince" Oana (24-10, 2.54 ERA, .303 BA) and slugging first baseman Bob Moyer (.295, 24 HR, 102 RBIs) finished second in the standings with a 91-63 record. In the playoff finals they met arch-rival Fort Worth and came out on top, four games to one.

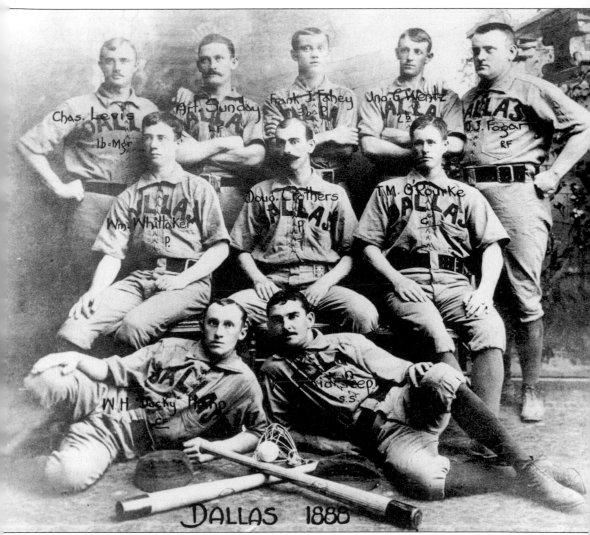

The inaugural season of the Texas League in 1888 saw many teams struggle with financial difficulties and several clubs fail to finish the season. In the end, however, the Dallas Hams claimed the pennant with a 55-29 record. From left to right: (front row) W. H. "Ducky" Hemp and William "Kid" Peeples; (middle row) William Whittaker, Doug Crothers, and T. M. O'Rourke; (back row) Charles Levis (manager), Art Sunday, Frank Fahey, John G. Wentz, and J. J. Fogarty.

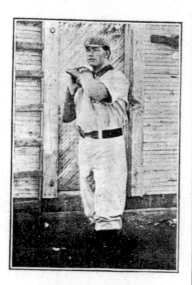

HUNTER

Fred C. Hunter, p.

Was born in Chillicothe, Ohio, 24 years ago; was with Cotton States League last year, but was taken sick with malaria fever. Manager Moran thought so well of him that he signed him. He is good, steady and understands the game from a to z.

Don't fail to study "A Concise Method of Scoring" as printed in these pages, for you can learn it quickly and will enjoy the games all the more.

E. M. Kahn can't be beat in school Children's Clothing.

Walter South, 1st b.

Was born in Willmington, Ohio, 24 years ago. In the years 1892 and 1893 he played with the Lancaster, Ohio, independent team, and signed this year with Dallas for 1904.

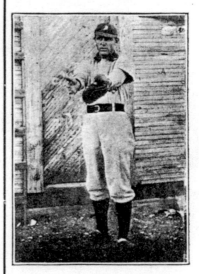

SOUTH

Shown here is a page from a 1904 Dallas Giants yearbook featuring pitcher Fred Hunter and first baseman Walter South. Led by infielder Lon Ury, who stole 56 bases, the Giants finished second in the four-team Texas League that season with a 58-45 record. The Dallas catcher in 1904 (and part of the next season) was a talented young Ohio native named Branch Rickey. He would go on to play parts of four seasons in the big leagues, but found greater success as a manager and then one of the game's most influential front office executives and team owners.

The playing manager of the Dallas Giants in 1903 was Charlie Moran. Together with third baseman Harry "Pep" Clark, who batted .319, he led the Giants to the 1903 Texas League pennant. The team finished the regular season with a 61-47 record and then defeated Waco, seven games to three, in a playoff series that was held entirely in Dallas. Moran received a call-up to St Louis that September, but he returned to manage the Dallas club again the following season. He eventually made it back to the Cardinals for part of the 1908 season as a back-up catcher. In 1909, Moran was hired as the head football coach at Texas A&M University and he held that position through the 1914 season.

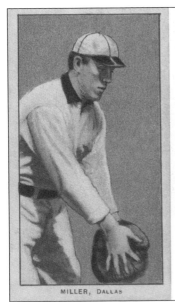 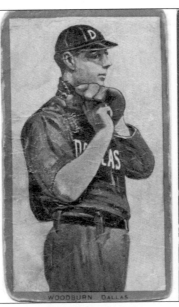 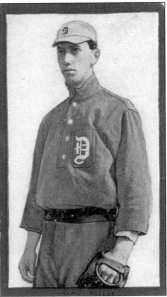

MILLER, DALLAS

WOODBURN DALLAS

In the early twentieth century, tobacco companies often inserted trading cards of baseball players in cigarette packs. These cards, *circa* 1910, feature Dallas players Molly Miller, Eugene Woodburn and Walter Hirsch. Woodburn would spend parts of the 1911 and 1912 seasons in the big leagues with the St. Louis Cardinals. Appearing in 31 games, he won two and lost nine.

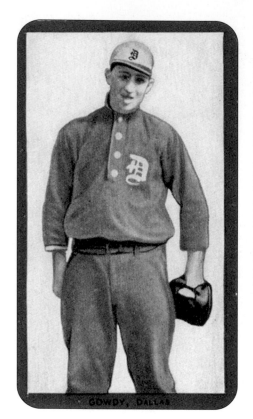

GOWDY, DALLAS

Twenty-year-old first baseman Hank Gowdy, seen here on a cigarette card, abused Texas League pitchers in 1910 as he helped lead the Dallas Giants to the pennant. He won the batting title with a .312 average, led the league with 44 doubles and tied for the lead with 11 home runs. Gowdy's performance earned him a promotion to the big leagues that September when the New York Giants purchased his contract. He eventually spent much of his 20 seasons in the major leagues as a catcher and first baseman with the Giants and the Boston Braves. The highlight of his career came in 1914, when he batted a record .545 during the World Series as he led the Braves to the title in an upset of the favored Athletics. Gowdy, who was the first major league player to enlist in the military during World War I, later had a long career as a coach with the Braves, Reds, and Giants.

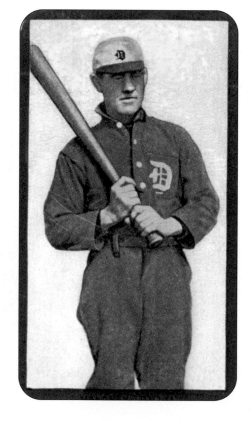

James "Curley" Maloney was perhaps the most prominent player of the Texas League's first quarter-century. A versatile performer who could play third base, hold down center field or even take an occasional turn on the mound, Maloney first came to the Texas League when he joined the Dallas Tigers in 1889. Between then and 1912, he would spend 17 seasons in the league, many of them as a player-manager, with several clubs. A player with Dallas in 1889 and 1892, he returned to the city in 1904. In 1905, he began what would be seven straight seasons at the helm of the club.

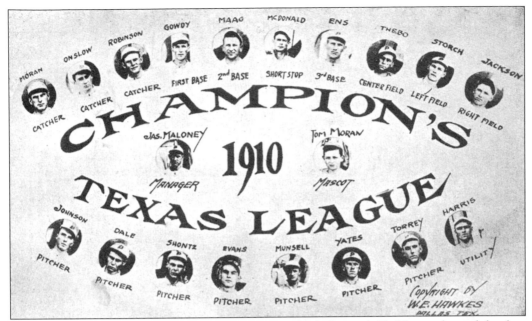

When the 1910 season ended, Dallas and Houston had identical 82-58 records, tied for first place. After much debate and suggestions that a playoff be held before the following season began, the league officially declared the two teams co-champions in the spring of 1911. From left to right: (front row) Rankin Johnson, Jean Dale, Walter Shontz, Evan "Rube" Evans, Emmett Munsell, R. Yates, Liz Torrey, and Harris; (middle row) James Maloney (manager) and Tom Moran (mascot); (back row) Charles Moran, Ed Onslow, Robinson, Hank Gowdy, Heinie Maag, Charles McDonald, Jewel Ens, A.V. "Tony" Thebo, Harry Storch, and George Jackson.

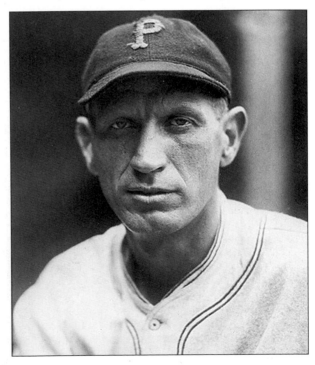

Infielder Jewel Ens, seen here in a 1920s photo, first joined the Dallas Giants in their championship season of 1910 and held down third base for the team through the 1912 season. Ens returned to Dallas for a second stint in 1915 that lasted five seasons. Always a consistent performer, he led the league with 96 runs scored in 1912, but had perhaps his finest season in a Dallas uniform in 1918, when he batted .303 and led the league in hits and runs scored. Ens finally reached the big leagues at age 32 and spent parts of four seasons as a utility infielder with Pittsburgh. He eventually moved into coaching with the Pirates and managed the team from 1929 through 1931. Ens later coached for the Boston Braves, Detroit Tigers and Cincinnati Reds.

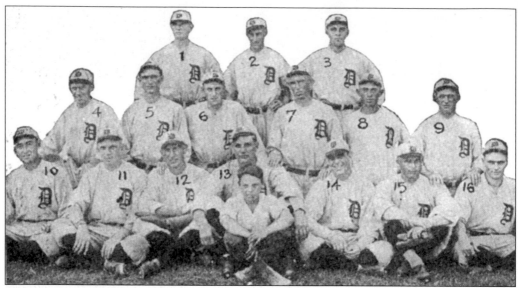

The 1916 Dallas Giants, seen here, finished in the Texas League cellar with a 58-85 record. It was a complete reversal of fortune the following season as the 1917 team (96-64) won the pennant by $6^1/_2$ games. From left to right: (front row) James Sewell, J.P. "Snipe" Conley, Jewel Ens, Jim Bluejacket, Smith, Wilbur "Peaches" Crouch, and Irvin Compere; (middle row) Godfrey "Red" Josefson, Gardner, John McCandless, Sam Lewis, Beddle, Ben Brownlow (manager); (back row) Smith, Bush, and Sparks.

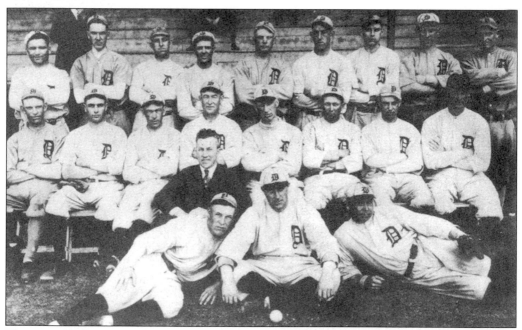

The 1917 Dallas Submarines were champions of the Texas League. From left to right (front row): unidentified, Lyman Smith, John McCandless, and Wilbur "Peaches" Crouch; (middle row) unidentified, Irvin Compere, Augustus, James Sewell, Jewel, Ens, Ben Brownlow, Clarence Brooks, and Hamilton Patterson (manager); (back row) Jerry Coleman, White, Eddie Palmer, Louis Litschi, Lynn Scoggins, Gus Bono, unidentified, and J.P. "Snipe" Conley.

J. Walter Morris is one of the most important figures in Texas League history. Born just east of Dallas in the town of Rockwall, Morris was a star infielder for Corsicana, San Antonio and Beaumont, among other teams. In 1908, he worked his way up to the major leagues for a brief trial with the St. Louis Cardinals. Morris eventually returned to Texas and served as manager, owner, and player with the Fort Worth Panthers. In 1916 he began what would be four years as president of the Texas League. Morris became a part owner of the Dallas Steers in 1922 and also led the team on the field for two-and-a-half seasons. After selling his Dallas interests in 1928, he remained involved in baseball for years, later serving as manager at Tyler, business manager at Shreveport and Fort Worth, and president of the East Texas, Cotton States, Big State and Evangeline Leagues before retiring in 1950. (Courtesy of the *Dallas Morning News*.)

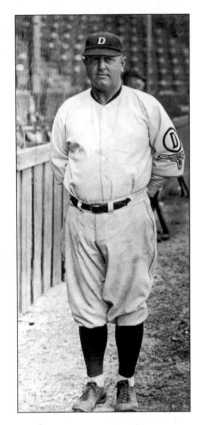

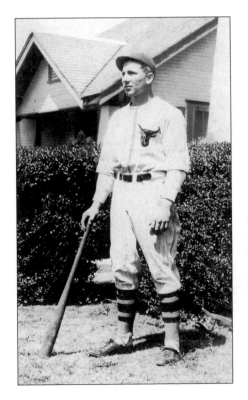

Seen here is an unidentified 1920s player in the uniform of the Dallas Steers. Dallas teams have gone by several nicknames over the years. The city's earliest professional team, in 1888, was named the Hams and later teams were called the Tigers (1889–90), the Navigators (1896), the Griffins (1902), the Giants (1903–1916) and even the Submarines (1917–1921). In 1895, and again from 1922 through 1938, Dallas' entry in the Texas League used the nickname Steers. The team then became known as the Rebels from 1939 through 1947, and the Eagles from 1948 through 1957.

17

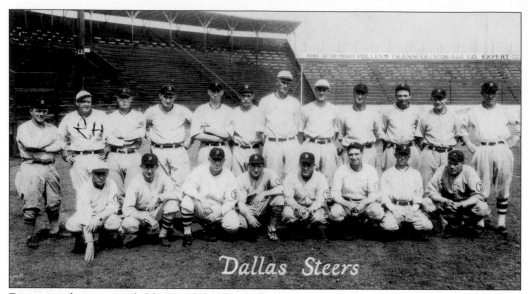

Dallas Steers

Featuring slugging outfielder Hack Miller (.321-30-118) and hard-throwing, 6'7" left-hander Slim Love (21 wins, 216 strikeouts), the 1926 Dallas Steers won the Texas League pennant and went on to take the Dixie Series by defeating New Orleans of the Southern Association. From left to right: (front row) Dick Schuman, Josh Billings, Fred Brainard, Elsh, Joe Tate, Berry, Costen (trainer), and Paddy Bauman; (back row) Charles "Hack" Miller, Scott Perry, Ewell "Turkey" Gross, Bud Hungling, McColl, Russell "Rusty" Pence, Edward "Slim" Love, M. E. Hunter, Rinaldo Williams, Walker, Hap Morse, and James "Snipe" Conley (manager).

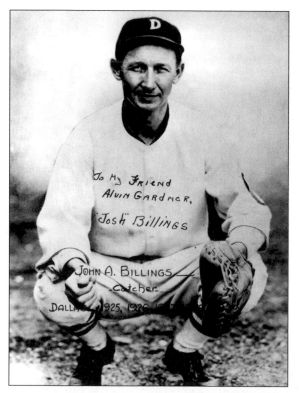

Josh Billings spent 11 seasons in the major leagues as a back-up catcher before joining the Dallas Steers in 1925. For five seasons he was a key member of the Steers' roster and he helped the team win pennants in 1926 and 1929. In 1926, Billings also hit an RBI triple in the deciding game of the Dixie Series against New Orleans to give Dallas the win. This photo is inscribed to Dallas businessman Alvin Gardner, who served as Texas League president from 1930 to 1953. (Courtesy of the *Dallas Morning News*.)

First baseman Henry "Zeke" Bonura began his baseball career with his hometown New Orleans Pelicans in 1929, and in 1932 he signed with the Dallas Steers. His first season in Dallas was an outstanding one. He batted .322 with 21 home runs and 110 RBIs and helped power the Steers to a second place finish in the league with a 98-53 record. The following season Bonura turned in one of the all-time great performances in the Texas League and was named Most Valuable Player when he hit for a .357 average and led the circuit in homeruns (24), RBIs (111) and runs scored (141). Bonura was sold to the Chicago White Sox the following season and went on to have a successful seven-year big league career.

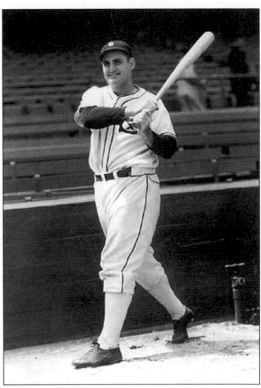

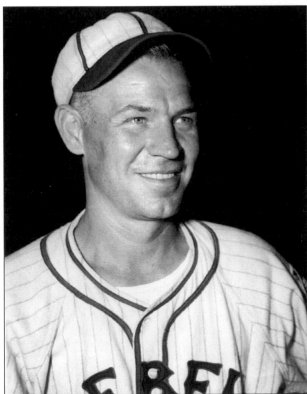

Sweetwater, Texas native Les Mallon spent four seasons in the big leagues as an infielder with the Phillies and the Braves before signing on to play for Dallas in 1936. He proceeded to win the batting title that first of three seasons in Dallas with a .344 average and was named Texas League MVP. Mallon helped the Steers run away with the regular season title in 1936 and finish nine games ahead of second-place Houston but unfortunately the team lost a hard-fought, seven-game playoff series with Tulsa.

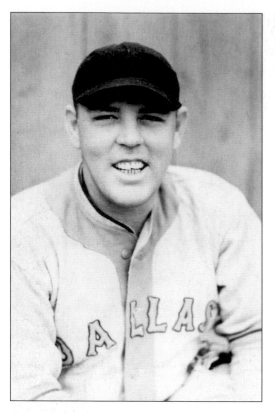

After eight seasons as the star backstop for St. Paul in the American Association, catcher Bob Fenner joined the Dallas Steers in 1938. Assigned to the Texas League by the Chicago White Sox, who were the parent club of both St. Paul and Dallas, Fenner batted .264 with 49 runs batted in. Despite a solid offense that included Fenner, league batting champ Harlan Pool (.330) and George Meyer, who led the league with 101 bases on balls, the Steers finished only seventh in the 1938 Texas League standings with a 65-94 record.

A notable member of the 1938 Steers was pitcher Paul "Daffy" Dean. A few seasons earlier, Dean had teamed with his brother Dizzy and Tex Carleton to give the St. Louis Cardinals "Gashouse Gang" a formidable pitching staff. As a rookie in 1934, he won 19 games for the Cardinals and was the star of the World Series, giving up only two runs in two complete-game wins. Dean again won 19 games the following season, but arm troubles soon began to plague him. Attempting to make a comeback, he spent the 1938 season in the Texas League and played for both Dallas and Houston. Dean wasn't particularly successful, however, and posted only an 8-16 record. He eventually did make it back to the major leagues for a couple of brief stays as a relief pitcher.

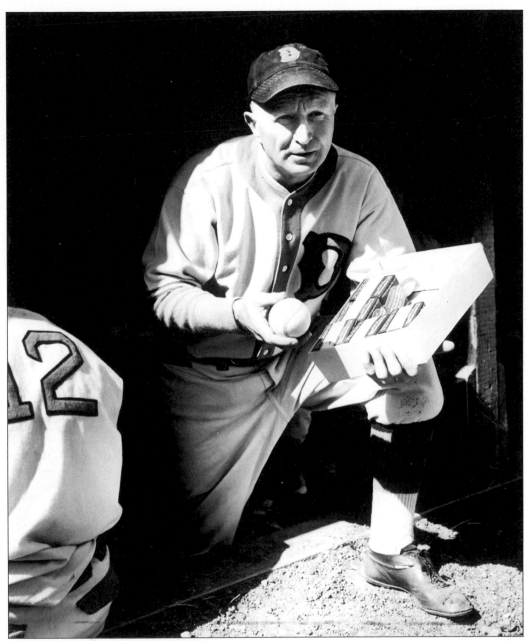

Ray Brubaker, who had played 15 seasons with Oakland in the Pacific Coast League, managed the Dallas Steers for parts of two seasons. With the Steers mired in last place in the Texas League in 1937, Brubaker was hired as the team's third manager of the season. He wasn't given much to work with, however, and the '37 Steers—perhaps the worst team to ever represent Dallas—finished in the league cellar with a record of 55-106, 47 games out of first. Brubaker returned in 1938 but was released midway through the season. The Steers went on to finish that season in seventh place (ahead of arch-rival Fort Worth) and with a record (65-94) slightly improved over the previous campaign. Ray Brubaker managed several minor league teams over the next decade, but his career came to a tragic end when he died of a heart attack in 1947 while in the dugout managing Terre Haute of the Three-I League. (Courtesy of the *Dallas Morning News*)

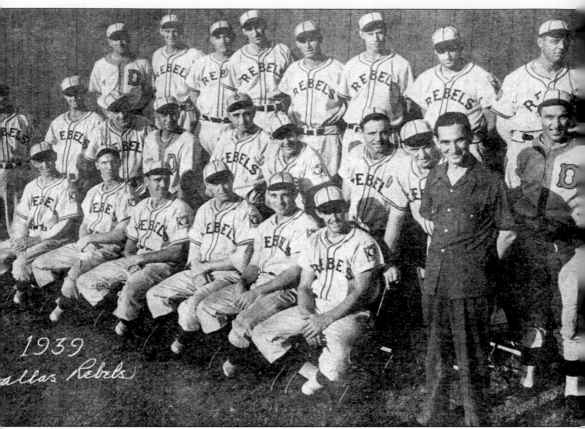

1939
Dallas Rebels

Manager Hap Morse led the 1939 Dallas Rebels to a second-place finish with a record of 89-72. The team defeated San Antonio in the first round of the playoffs but lost to Fort Worth, four games to one, in the finals. From left to right: (front row) Sal Gliatto, Lloyd Rigby, Jere Moore, Clay Touchstone, Grey Clarke, Bob Uhle, and George Schepps (president); (middle row) Hap Morse (manager), Joe Demoran, Bill Cronin, Les Mallon, Phil Seghi, Jim Levey, Roy Mort, Myron "Red" Hayworth, and Clary Hack; (back row) Charles Smith, Earl Overman, H.G. Lee, H.B. Lee, Cecil Trent, George Puccinelli, and Beryl Richmond.

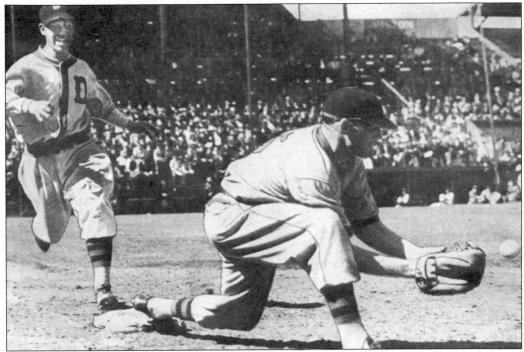

In a faked photograph from a 1940 program, Dallas utility player Luke Wilborn attempts to beat out a throw to Dallas first baseman Roy Mort. Winborn had been a good player in the East Texas League, but he only appeared in a few games for Dallas. Mort, however, held down first base for the Rebels for three seasons and was twice selected to the Texas League Al-Star team. He joined the team in 1939 after several years in the Pacific Coast League. Despite the best efforts of Mort (.281 batting average), pitcher Bob Uhl (a league-leading 205 strikeouts) and manager Hal Lee, the Rebels finished only sixth in the 1940 Texas League standings.

Gordon Maltzberger, a native of the Texas Hill Country town of Utopia, joined the Dallas Rebels in 1941. Already a veteran of several minor league seasons, he pitched well and posted a 15-16 record with 144 strikeouts and an ERA of 2.69. Maltzberger returned to the Rebels in 1942, but was sold to Shreveport late in the season as that team made a push for the pennant. For the season, Maltzberger won 16 games and had a 2.57 ERA. The following spring he made the Chicago White Sox roster and with that team became one of the first pitchers to be used in a completely relief role. Appearing in 135 games, Maltzberger twice led the American League in saves. He later went on to spend several seasons with Hollywood in the Pacific Coast League.

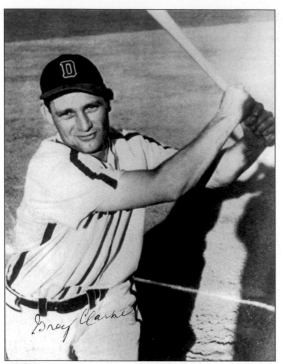

Third baseman Grey Clarke joined the Dallas ball club in 1938 for the first of what would be four seasons with the team. In 1941, he had his best year, driving in 96 runs and batting .361 to win the Texas League batting title. Clarke's offensive production that season, combined with that of first baseman Heinz Becker (.319) and the pitching of veteran Sal Gliatto (21-10), helped the Rebels win the league playoffs, first defeating Houston and then Tulsa. After a long minor league career that also included a season with Houston, Clarke finally made it to the big leagues in 1944 at age 31. In 63 games with the White Sox that season he batted .260. (Courtesy of Hank Utley.)

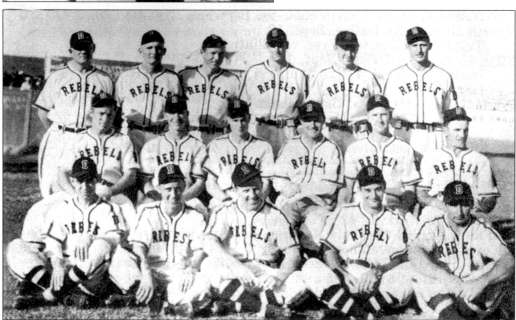

The 1941 Dallas Rebels finished the regular season in fourth place with an 80-74 record, but qualified for the playoffs. They went on to take the Texas League pennant, but in the Dixie Series against Southern Association champs, Nashville, the Rebels were swept in four games. From left to right: (front row) Sal Gliatto, Leslie "Bubber" Floyd, Bill Cronin, Joe Demoran, and George Jansco; (middle row) John Stoneham, Lloyd Rigby, Garth Mann, Wally Dashiell (manager), Gordon Maltzberger, and Nick Gregory; (back row) Paul Easterling, Otho Nitcholas, Roy Mort, Eldred Beasley, Myron "Red" Hayworth, Heinz Becker.

Though President Roosevelt believed baseball should continue during World War II as an important source of morale on the home front, the minor leagues struggled. Teams had to deal with player shortages, travel difficulties and an overall decline in attendance. Though some minor leagues suspended operations in 1942, the Texas League continued play. It proved to be a particularly unsuccessful season for the Dallas Rebels as they finished last in the league with a 48-104 record and a total attendance figure of only 37,107. With many teams facing financial hardship, the Texas League ceased operation after the season. It would be 1946 before professional baseball returned to Dallas.

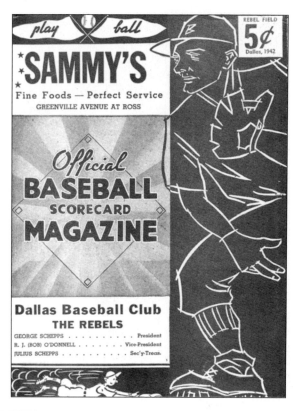

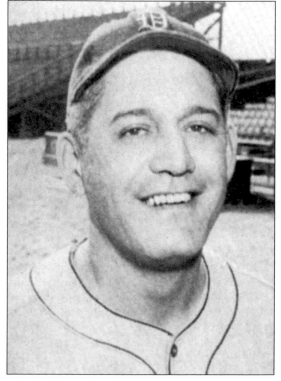

In his 23-year career, Henry "Prince" Oana played for minor league teams in San Francisco, Atlanta and Syracuse among others. He also spent three seasons in the Texas League with Fort Worth and made it into a handful of major league games. In 1946, at age 38, the Hawaii native signed with the Dallas Rebels. Primarily a pitcher, but also playing in the outfield, he had a terrific season and finished with a 24-10 record, a 2.54 ERA, and a .303 batting average in 61 games. Named "Pitcher of the Year," Oana helped the Rebels take the Texas League pennant. He returned to the team in 1947 and, though not as effective on the mound, he still hit .375 in limited action. After that season Oana turned to managing and guided both Austin and Texarkana in the Big State League.

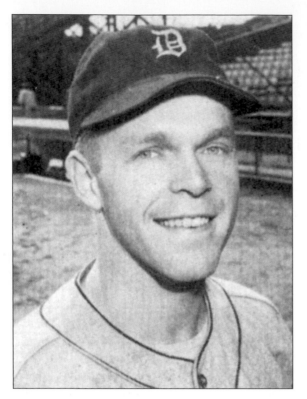

Gene Markland played his first professional baseball with the Henderson Oilers of the East Texas League in 1939. After playing for several teams on the East Coast and spending four years in the military, he signed with the Dallas Rebels in 1946. A key member of the pennant-winning team that season, Markland held down second base and batted .291. He again played well for the Rebels in 1947, hitting .273, before moving up to play for Milwaukee and Buffalo. Markland finally got a big league "cup of coffee" in 1950 with the Philadelphia Athletics before returning to the high minor leagues for a couple of more seasons.

Up until the 1950s, it was common for former major league players to finish their careers in the minor leagues. Such was the case with infielder Ed "Red" Borom. After a long climb up the minor league ladder, Borom spent parts of two seasons with the Detroit Tigers. He then returned to the minors and in 1946 signed with Dallas. He spent two and a half seasons with the team as a utility infielder before moving on to play in the Big State league for Texarkana, Paris and Greenville. Borom retired during the 1950 season while with the Fort Worth Cats.

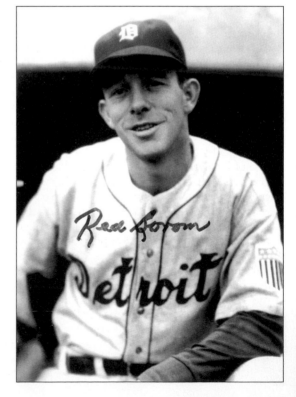

TWO

Dick Burnett and the Dallas Eagles

A new era in Dallas baseball began in the spring of 1948 when East Texas oilman R.W. "Dick" Burnett bought the club from George Schepps. Paying $550,000, he set a record for the highest total ever paid for a minor league club. Burnett, a baseball enthusiast who had owned smaller franchises in towns such as Texarkana and Gainesville, changed the name of the team to the Eagles in 1949, and the name of the 10,500-seat stadium (which he also purchased) to Burnett Field that same season.

Under Burnett's leadership, the Eagles flourished. The teams set all-time Texas League attendance record of 404,851 in 1949, finished first in the regular season standings three times, won one pennant, and beat Nashville in the 1953 Dixie Series, a best-of-seven playoff against the champion of the Southern Association. In 1950, Burnett, ever the expert publicist, drew national attention as he hired a team of legendary retired ballplayers for the season opener. The heavily promoted stunt paid off as over 53,000 fans turned out for the game. The following season, after three years of operating as an independent club, Burnett signed a working agreement to become an affiliate of the Cleveland Indians. The Eagles later joined the New York Giants farm system.

One of Burnett's greatest contributions to baseball was the integration of the Texas League. Before the 1952 season he announced his intentions to bring the first black player into the league. Burnett began a search for a suitable candidate, and after a couple of failed efforts during spring training he settled upon 27-year-old pitcher Dave Hoskins. On April 13, 1952, the color barrier in the Texas League was officially broken when Hoskins took the mound against the Tulsa Oilers. Burnett's selection proved to be the perfect one as Hoskins handled the pressure both on and off the field extremely well. With his 22-10 record and 2.12 ERA he helped the Eagles finish on top of the league standings. Because of the integration of the Eagles, local black leaders in Dallas honored Burnett when the Noonday Luncheon Club of the Moorland Branch of the YMCA presented Burnett with a plaque inscribed to "The One Who Has Done The Most To Improve Race Relations in 1952".

Though some Texas League teams would remain segregated for several more seasons, Burnett never shied away from hiring black players. He soon brought in others including former Negro League stars Buzz Clarkson and Terris "Speed" McDuffie. Clarkson, who joined the Eagles in 1953, had a couple of big offensive seasons. McDuffie, who had led the Homestead Grays to the

pennant with a 27-5 record in 1941, was 44 years old when Burnett brought him to Dallas in 1954. Used primarily as a relief pitcher, he turned in a solid performance as he wrapped up his long career with the Eagles. Burnett knew bringing in Hoskins, Clarkson and others would attract the area's black baseball fans (attendance, though down across the league in 1952, was up significantly for the Eagles) but he also hired them because they could play ball. He may have been a great promoter, but, above all else, Burnett wanted his team to succeed.

The 1950s were a difficult time for minor league baseball across the country as fans turned to other forms of entertainment, including major league games on television. Burnett fought for the rights of minor league baseball franchises and even organized a conference of minor league owners, but he also understood that a relationship between the major and minor leagues had become necessary. Since he was a great believer in the notion that the Dallas area would make a good site for a big league team, Burnett also had to maintain a good relationship with the major leagues. For his efforts, he was named Minor League Executive of the Year by *The Sporting News* in 1954.

Before his death from a heart attack in 1955 (while in Shreveport to watch his Eagles play), Burnett had pushed Dallas as a major league site. He upgraded Burnett Field into one of the best minor league ballparks in the country. After his death, his wife and daughters operated the team until 1959, when they sold it to Fort Worth businessmen J.W. Bateson and Amon Carter, Jr.

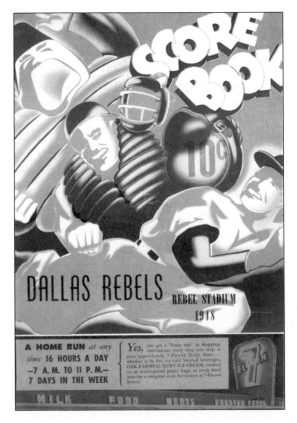

Dick Burnett took over operation of the Dallas ball club shortly before the start of the 1948 season. Just like major league clubs, teams in the high minors often had lower-level affiliates. Burnett made his new purchase the top of a pyramid that included two other teams he owned, Gladewater in the Lone Star League and Texarkana in the Big State League, as well as Lubbock in the West Texas-New Mexico League and Odessa in the Longhorn League.

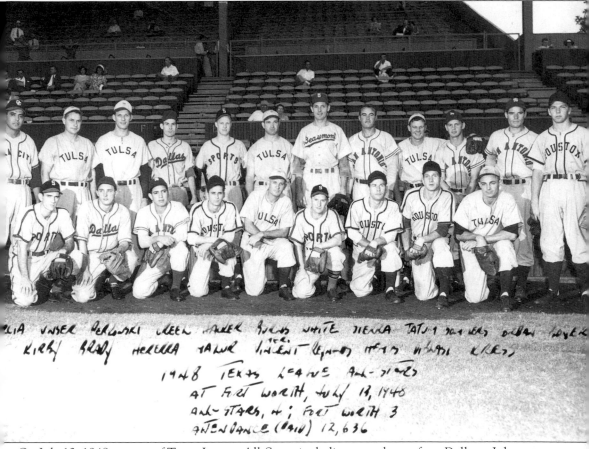

On July 13, 1948, a team of Texas League All-Stars, including two players from Dallas—Johnny Creel and Bob Brady—took on the Fort Worth Cats at LaGrave Field in Fort Worth. The All-Stars prevailed in the contest, 4-3, in front of 12,636 fans. In the front row, from left to right, are Jim Kirby, Bob Brady, Procopio Hererra, Pete Mazur, Al Vincent (manager), Dan Reynolds, Solly Hemus, Sam DiBiasi, and Charlie "Red" Kress. In the back row are Mike Garcia, Al Unser, Harry Perkowski, Johnny Creel, Warren Hacker, Russ Burns, Bill White, Andy Sierra, Tom Tatum, Tom Jordan, and Cloyd Boyer.

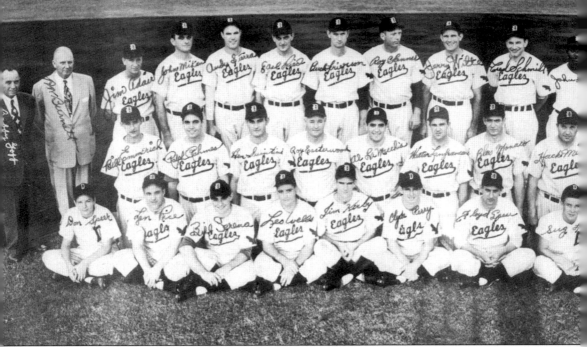

For the 1949 season Burnett renamed his team the Dallas Eagles. They finished only fifth in the eight-team Texas League, with a record of 76-77, but their attendance total of 404,851 led the league by more than 115,000. The Eagles lineup included, from left to right: (front row) Don Speer (bat boy), Len Rice, Bill Serena, Les Wells, Jim Kirby, Clyde Perry, Floyd Speer, and Sug Long (bat boy); (middle row) Bill Emmerich, Ralph Rahmes, Ben Guintini, Roy Easterwood, Al La Macchia, Walter Lafrancois, Blas Monaco, and Hack Miller; (back row) Bobby Goff (business manager), R.W. "Dick" Burnett (owner), Jim Adair (manager), John Mikan, Andy Sierra, Earl Reid, Buck Frierson, Roy Channel, Jerry Witte, Fred Schmidt, and John Hopps (trainer).

The baseball career of Arkansas native Floyd Speer began with Hot Springs in 1938, and in 1942 he helped Shreveport take the Texas League pennant with a 17-win season. Though he did pitch three relief innings for the Chicago White Sox during the war, Speer never really made it in the major leagues. He did, however, have three standout seasons with Oakland in the Pacific Coast League. He made his way to Dallas in 1949 and pitched well, winning ten games for the fifth-place Eagles. In 1950, Speer moved on to Little Rock in the Southern Association and he retired in 1953 after two seasons with the Texarkana Bears of the Big State League.

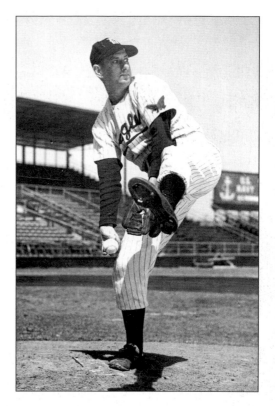

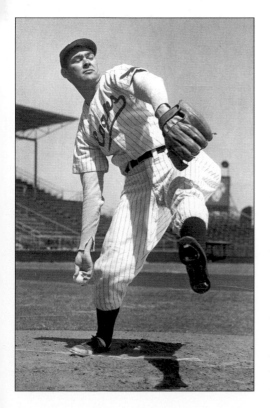

Right-handed pitcher Reuben Fischer, seen here about to deliver a pitch during a spring practice session, played for Dallas in 1949. The South Dakota native, who had his best professional season with Sioux City when he went 21-6 with a 2.49 ERA in 1938, worked his way up through the minors and eventually reached the big leagues. Between 1941 and 1946 he made it into 108 games, primarily as a middle reliever, with the New York Giants. After the 1948 season Fischer was released by the Giants organization, and he signed with the Dallas Eagles for 1949. His stay in Dallas was short, however, and he eventually played with Tulsa for several games during that season before retiring.

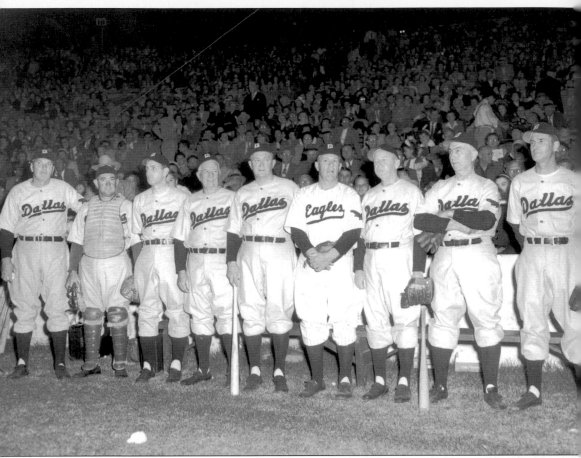

Dick Burnett pulled off his most spectacular feat as a baseball owner on April 11, 1950. Attempting to shatter the Texas League Opening Day attendance record (16,018 at Fort Worth in 1930) and hoping to establish an all-time minor league attendance mark, he secured Dallas' famous football venue, the Cotton Bowl, for the game against Tulsa. To bring in the fans Burnett hired nine legends of the game to come out of retirement and suit up for the Eagles. The stunt drew nationwide attention and ticket sales were brisk. In the end, the game, which was preceded by a parade from downtown to the Cotton Bowl, drew 53,578 fans to the stadium. After batting practice by Burnett's new hires, Governor Alan Shivers threw out the first pitch and the "Eagles" took the field. Dizzy Dean pitched to one Tulsa batter and walked him before the celebrities surrendered the field to the real Eagles team. Burnett's team of famous old-timers, seen here from left to right, consisted of Dizzy Dean, Mickey Cochran, Charlie Gehringer, Tris Speaker, Ty Cobb, Charlie Grimm, Duffy Lewis, Frank 'Home Run' Baker and Travis Jackson. (Courtesy of the Texas/Dallas History and Archives Division, Dallas Public Library.)

Jim Kirby, seen here in action, was the Dallas Eagles center fielder from 1949 to 1951. Kirby's career began with Tyler of the East Texas League in 1946 and also included stops in the Texas cities of Gainesville, Paris, and Port Arthur before he retired in 1958. Early in the 1949 season Kirby made it into three games as a pinch hitter with the Chicago Cubs before being sent back down to play for his hometown Nashville Vols in the Southern Association. After only a few weeks in Nashville, however, his contract was sold to Dallas, where he batted .270 for the remainder of the season. Kirby returned to the Eagles in 1950, batting .280, and played 44 games with the team the following season before being traded to Tulsa.

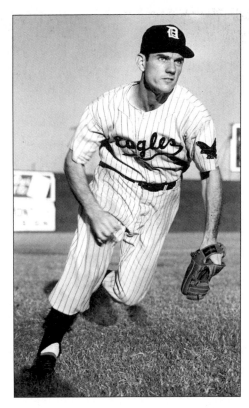

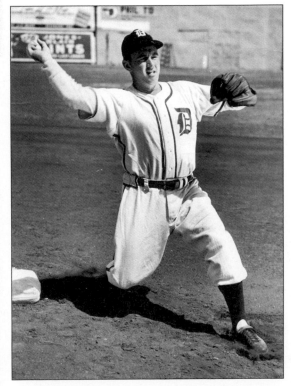

Versatile infielder Bob Cullins, who hit .305 for the 1951 Dallas Eagles, had an interesting baseball career in that all of it was spent in the state of Texas. His first professional club was Texarkana in 1946 and by the time he retired from the playing field after the 1955 season he had also worn the uniforms of Gladewater, Gainesville, Dallas, Fort Worth, Longview, Greenville, Bryan, Tyler and Odessa.

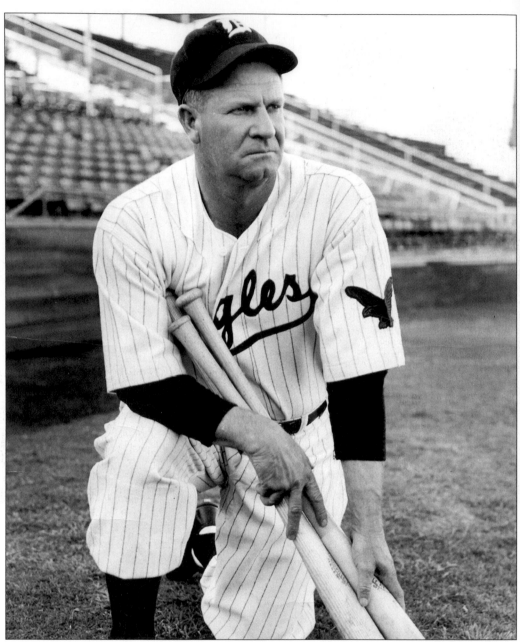

A native of Linden, Texas, Vernon Washington began his professional baseball career in 1931. On his way up the minor league ladder he spent time in the Texas League with Fort Worth and Tyler before making it to the big leagues with the Chicago White Sox for all of 1935 and part of 1936. He went on to win an American Association batting title with St. Paul, and then spend four years as a standout outfielder with Shreveport in the Texas League before the war interrupted his career. After the war, Washington returned to baseball and played three seasons with Texarkana, where he served as player-manager and won two Big State League batting titles. In 1949, he joined Gladewater in the East Texas League, and then signed with Dallas for 1950, a season that would be his last in the game. At 43 years old, Washington proved he could still hit Texas League pitching, batting .278 in 36 games, before returning to Gladewater to finish the season.

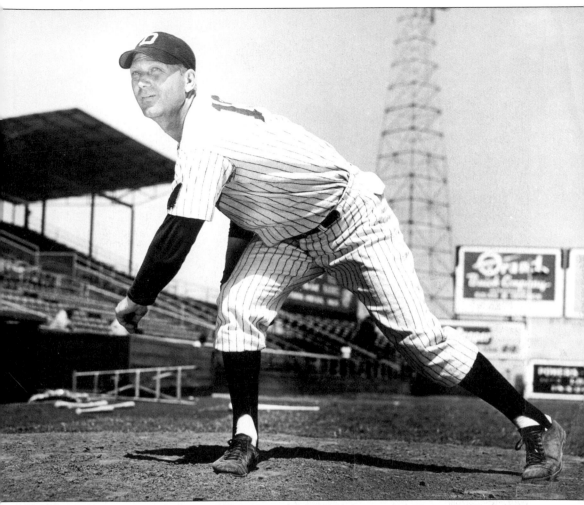

Roy "Tex" Sanner was a combination pitcher-outfielder for his entire 17-year minor league career and in 1948, while playing for Houma, Louisiana, in the Evangeline League, he had perhaps the most impressive season any baseball player has ever had. On the mound he was 21-2 with 251 strikeouts and an ERA of 2.58. At the plate Sanner did nothing less than win the Triple Crown, batting.386 with 126 RBIs and 34 home runs. Needless to say, that performance attracted the attention of teams across the country and Sanner was signed by Dallas for the final few games of the season. In 1949, he played well for the Eagles and hit .333 in 63 games while winning nine games on the mound. Sanner spent parts of 1950 and 1951 with Dallas as well, splitting both seasons with Gainesville of the Big State League.

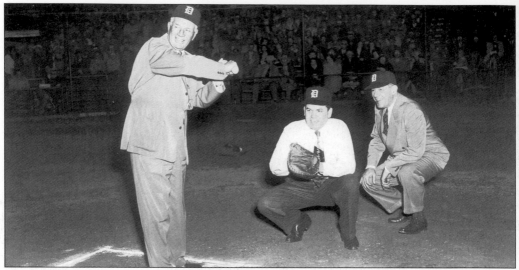

Tris Speaker, a native of Hubbard, Texas, is one of baseball's all-time greats. As an 18-year-old rookie with Cleburne in the Texas League in 1906, Speaker batted .268, stole 33 bases, and displayed impressive fielding skills. The following season he signed with Houston, where he proceeded to win a Texas League batting title with his .314 average. He was signed by the Boston Red Sox that September and would spend the next 22 seasons patrolling outfields in the American League. Speaker retired with 3,514 hits, a career batting average of .345, and became one of the five players selected to be the first inductees into the Baseball Hall of Fame. In this photo, Speaker, at bat, is seen taking part in Opening Day festivities at Burnett Field in 1951. Dallas District Attorney Henry Wade is serving as catcher while Sheriff Bill Decker is the umpire. (Courtesy of the Texas/Dallas History and Archives Division, Dallas Public Library.)

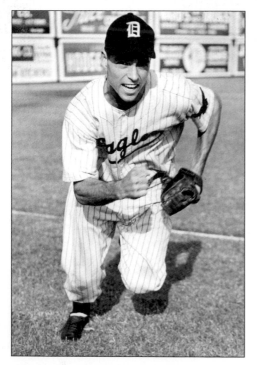

The professional baseball career of outfielder Ken Mapes began in 1944 and saw him play for clubs on both coasts of the country, as well as in the Midwest, while a member of the Cleveland Indians farm system. In mid-1950, the Indians sent him to Oklahoma City in the Texas League where he batted .280. When the Indians switched their Texas League affiliate from Oklahoma City to Dallas for the 1951 season, Mapes was one of several players to be reassigned to the Eagles. Primarily used as a fourth outfielder, he played well with Dallas, but was released late in the season to make room for a promising younger player. Mapes then signed on with league rival Tulsa. He finished out his playing career in 1953 with Austin in the Big State League.

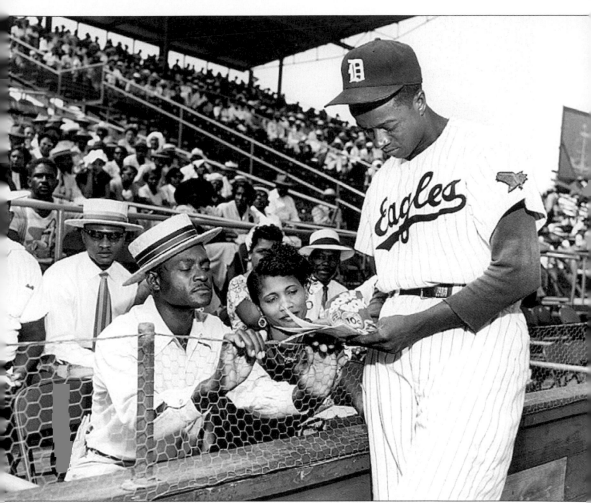

While Jackie Robinson was called baseball's "Great Experiment" when he integrated the major leagues in 1947, pitcher Dave Hoskins played the same role in the Texas League in 1952. Dick Burnett had been determined to bring a black player into the league and his selection of Hoskins, a former star with the Homestead Grays, proved to be a gamble that paid off brilliantly. Not only did Hoskins, seen here signing an autograph for a fan, handle the pressure admirably, he had an incredible season on the field. With a 22-10 record, a 2.12 ERA and even a .328 batting average, Hoskins helped the Eagles finish the regular season on top of the league standings. In 1953, Hoskins made the Cleveland roster out of spring training and, appearing in 26 games, he won nine and lost three. The 1954 season was split between Cleveland and the Indians top farm club in Indianapolis. After a couple of more seasons at the top level of the minor leagues, Hoskins returned to Dallas in 1958. He again had an outstanding season on the mound, winning 17 and losing eight with an ERA of 3.18. Hoskins played for Dallas again in 1959, but was dealt to Houston in mid-season. He retired from the playing field after the 1960 season.

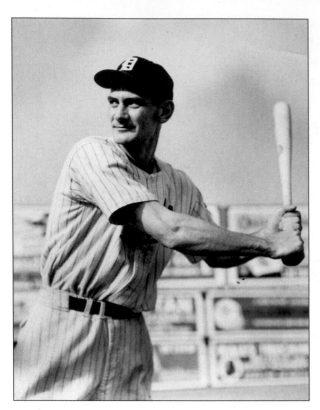

First baseman Herb Conyers joined the Eagles a month into the 1951 season from San Diego of the Pacific Coast League. A well-traveled veteran who had won a Texas League batting title with Oklahoma City in 1949 and gotten into a few games with the Cleveland Indians in 1950, the 6'5" Conyers played well for Dallas and hit .293 in 115 games. He split the 1952 season between Indianapolis and Birmingham before retiring from the playing field.

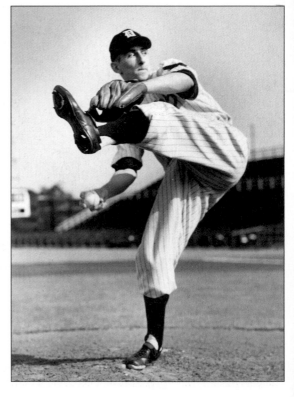

The Cleveland Indians assigned 22-year-old top pitching prospect Ray Narleski to Dallas for the 1951 season. The young right-hander pitched well for the Eagles and turned in a 15-8 record with an earned run average of 2.42, one of the best in the league. Narleski went on to make his big league debut with Cleveland in 1954 and even appeared in two World Series games that season. In 1955, he was the top relief pitcher in the American League, with a 60 appearances, a 9-1 record, and 19 saves.

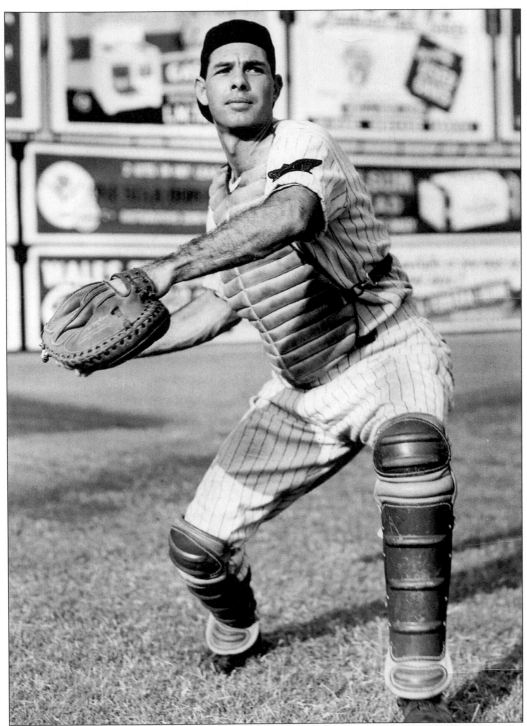

Dick Kinaman split the catching duties for the Dallas Eagles with Dick Aylward in 1951. Light-hitting but good with the glove, he batted .245 with 20 RBIs in 72 games. During his well-traveled playing career, Kinaman would also take the field for Texas League clubs in Oklahoma City, Tulsa and Shreveport before becoming a manager in the minor leagues.

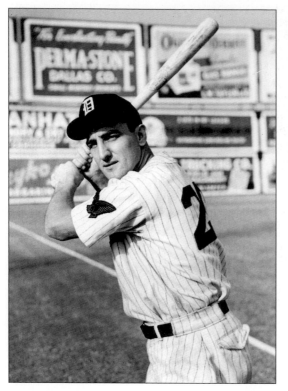

Rightfielder Jim Fridley batted .299 and drove in 74 runs in 1951, his one season in Dallas. He made the Cleveland Indians roster out of Spring Training in 1952 and saw action in 52 games before being sent down to Indianapolis. During a long career in professional baseball that began in 1948, Fridley had three short stays in the major leagues, but he found his greatest success in cities in the high minor leagues such as Denver, Nashville, San Antonio and Houston. He closed out his playing career in the game in 1961 with Ardmore in the Texas League.

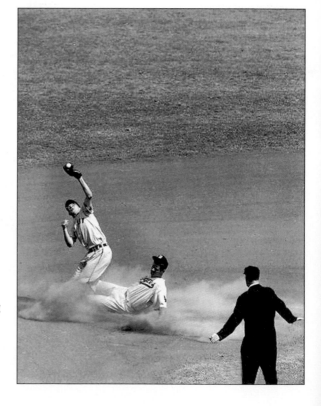

The Eagles' Harry Scherting is called safe at second base during a 1952 game. Scherting, who began his career with Vernon in the Longhorn League in 1948, played for several Texas minor league teams including Gainesville and Gladewater. After batting .371 in the first half of the 1952 season with Longview of the Big State League, He received a promotion to Dallas, where he batted .288 with 49 RBIs. Scherting spent the 1953 season with the Fort Worth Cats before retiring from the game.

Left-hander Ed Varhely was one of the Texas League's top relief pitchers in 1951, appearing in 48 games for the Dallas Eagles and winning six with an earned run average of 2.73. Still with the Eagles the following season, he turned in a 3-2 record with a 3.11 ERA. In 1953, Varhely joined the Tulsa Oilers and helped them claim second in the Texas League with his six wins. He finished his career with Havana and Atlanta in 1954.

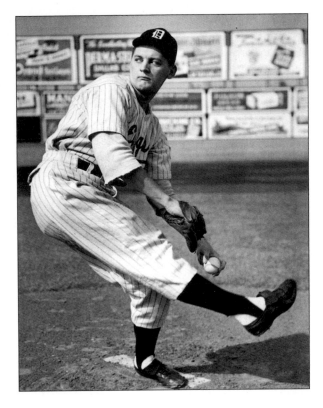

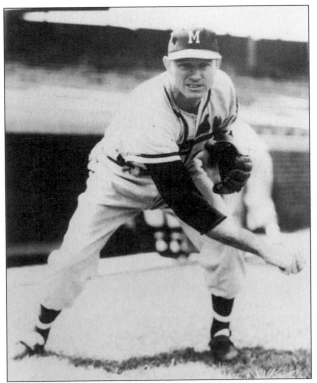

After successful seasons on the mound for Texas City and Tyler (19 and 23 wins, respectively), John "Red" Murff signed with the Dallas Eagles in 1953 and pitched three seasons with the team. His best came in 1955, when he posted a 27-11 record and had an earned run average of only 1.99. Named Texas League Pitcher of the Year for that performance, Murff was also selected as Minor League Player of the Year by *The Sporting News*. The following spring Murff made his big league debut with the Milwaukee Braves, where he would spend parts of two seasons. After wrapping up his career as player-manager for Jacksonville, Florida, in 1960, Murff turned to scouting. His greatest discovery, whom he signed for the New York Mets, would also go on to have an impact on Dallas area baseball: Hall of Fame pitcher Nolan Ryan.

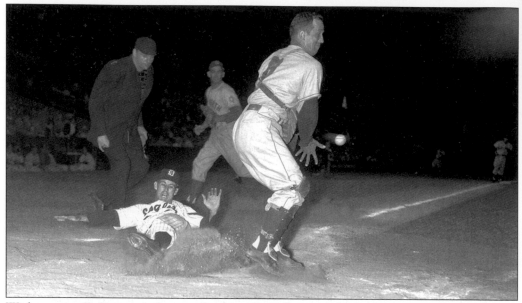

With umpire Si Simon ready to make the call, Dallas outfielder Johnny Creel slides home as Fort Worth catcher Ted Bosiack reaches for the catch in a 1952 game. It was a close race that season between the Eagles and their arch-rivals, the Fort Worth Cats. Creel, who played for Dallas during the 1947 and '48 seasons and again in '52, batted .261 and drove in 51 runs as he helped the Eagles hold on to first place and finish six games ahead of the Cats. The team advanced to the playoffs, but was upset by the Oklahoma City Indians in the first round. (Courtesy of the Texas/Dallas History and Archives Division, Dallas Public Library.)

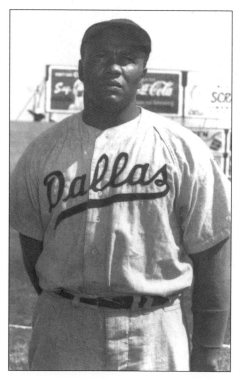

James "Buzz" Clarkson was one of the many players whose career was hindered because of the color of his skin and the segregation of baseball. A star in the Negro Leagues with the Pittsburgh Crawfords and Philadelphia Eagles, as well as with teams in Mexico and Puerto Rico since 1937, Clarkson joined the organized minor leagues when he signed with Milwaukee of the American Association in 1950. Two years later, though past his prime at age 34, he finally got a chance in the big leagues when he made the Boston Braves roster out of Spring Training. Clarkson appeared in a handful of games before being sent back down to Milwaukee. The following season he signed with Dallas to play third base. He apparently found Texas League pitching to his liking as he hit .330 with 18 home runs and 87 RBIs. Back with the Eagles in 1954, Clarkson put up career-high numbers, slugging a league-leading 42 home runs and driving in 135 runs. He retired from the playing field after splitting the 1956 season between Los Angles, Tulsa and Des Moines. (Courtesy of the Texas/Dallas History and Archives Division, Dallas Public Library.)

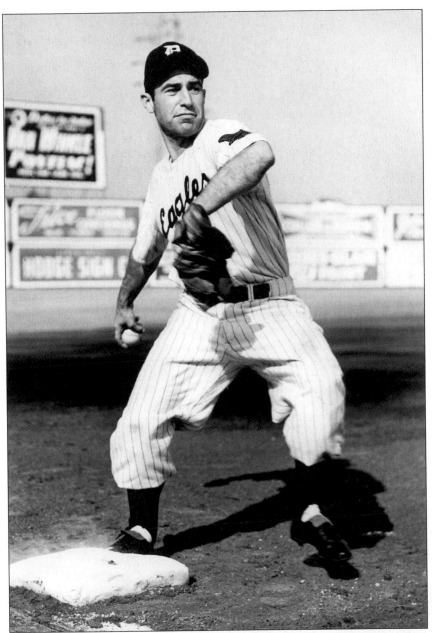

A slick-fielding third baseman who was chosen "Most Popular" by Dallas fans, Frank Tornay was a member of the Eagles for four full seasons, from 1951 through 1954. The San Francisco native played a key role in the Eagles' 1953 championship, batting .292 with a team-high 37 doubles during the regular season. In league championship play that season he hit .356, and then batted an impressive .423 with five RBIs in the Eagles' Dixie Series win over the Nashville Vols. In 1955, Tornay played a few games in the Texas League for Dallas and Beaumont but most of the season was spent in the Big State League with Galveston, Port Arthur and Harlingen. He signed with Plainview, Texas, for the 1956 season, where he also served as manager, and retired in 1957.

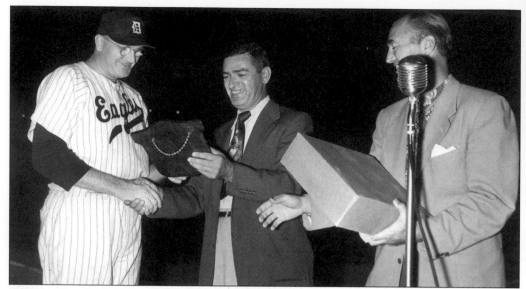

After back-to-back 20-win seasons with Quebec in the Canadian-American League, pitcher Hal Erickson signed with Dallas for 1951. That first season with the Eagles the 6'5" right-hander turned in a 12-10 record with a 2.46 ERA. In 1952, he was even better, posting a 20-14 record with an earned run average of 2.60. He is seen here being presented with the Texas League's 1952 Pitcher of the Year Award by sports editors Bill Rives of the *Dallas Morning News* (left) and Louis Cox of the Dallas Times Herald. The following spring Erickson made the Detroit Tigers roster as a relief pitcher. He appeared in 18 games with one save, a record of 0-1, and an ERA of 4.73. (Courtesy of the Texas/Dallas History and Archives Division, Dallas Public Library.)

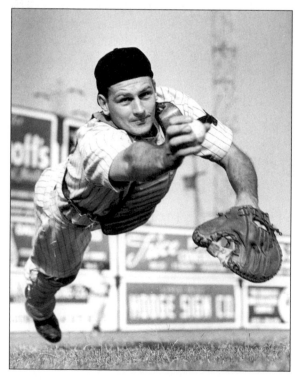

Catcher Dick Aylward spent three full seasons (1950-1952) as the Dallas Eagles' backstop. Though never much of a threat at the plate, Aylward was defensively outstanding and his fielding and throwing skills helped him have a long career in baseball. After leaving Dallas, Aylward even got the call to join the Cleveland Indians early in the 1953 season. Hitless in four games, he was sent down to Indianapolis. Aylward never made it back to the big leagues, but he did go on to spend five seasons in the Pacific Coast League with San Diego and Seattle.

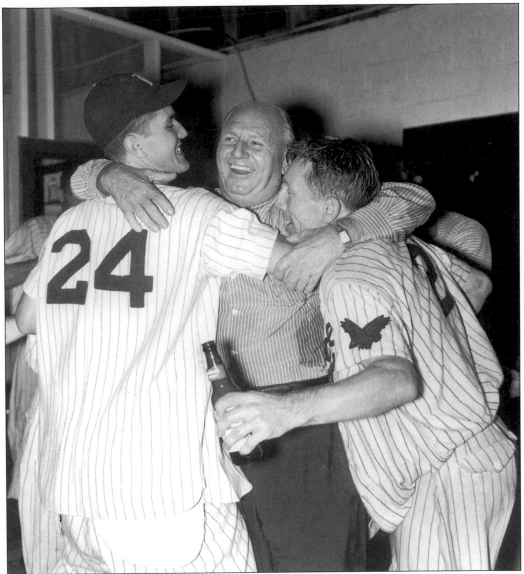

The owner of the Dallas Eagles, Dick Burnett (center) is seen here celebrating with first baseman Joe Macko (left) and Bob Bundy after his team won the Texas League regular season title on September 5, 1952. While Burnett is a legendary figure in Dallas baseball, Joe Macko, one of the players in this photo, is not far behind. Macko played for Dallas during the 1951 and '52 seasons and again in 1956, then served as general manager of the Dallas-Fort Worth Spurs for several seasons during the 1960s. When major league baseball came to town, he was hired as business manager and later became visiting clubhouse manager. When he retired in 2000, the popular Macko was the Rangers' last original employee from the team's first season in Texas. (Courtesy of the Texas/Dallas History and Archives Division, Dallas Public Library.)

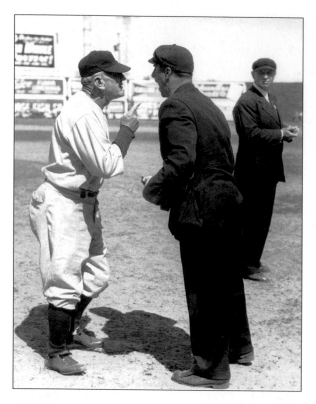

New York Yankees' manager Casey Stengel and umpire Augie Donatelli argue during an exhibition game between the Yankees and Dallas Eagles at Burnett Field in the early 1950s. Over the years, many major league teams made pre-season stops in Dallas for exhibition games as they made their way home after spring training. In a particularly thrilling spring game in 1929, Babe Ruth and Lou Gehrig both hit home runs to lead the Yankees to a 12-11 win over the Dallas Steers. (Courtesy of the Texas/Dallas History and Archives Division, Dallas Public Library.)

The first radio broadcast of a Texas League game took place in 1922 in Fort Worth, and it wasn't long before other teams also began to take advantage of the new way to reach fans. Over the years several AM stations, including WRR 1310 and KLIF 1190, broadcast Dallas minor league games. Major league baseball also made its way to Dallas over the airwaves. For many years the St. Louis Cardinals had a strong following in the Dallas area thanks to the local broadcasts of their games.

Support the DALLAS EAGLES dial KLIF 1190 J-B PAINTS SPONSORED BY

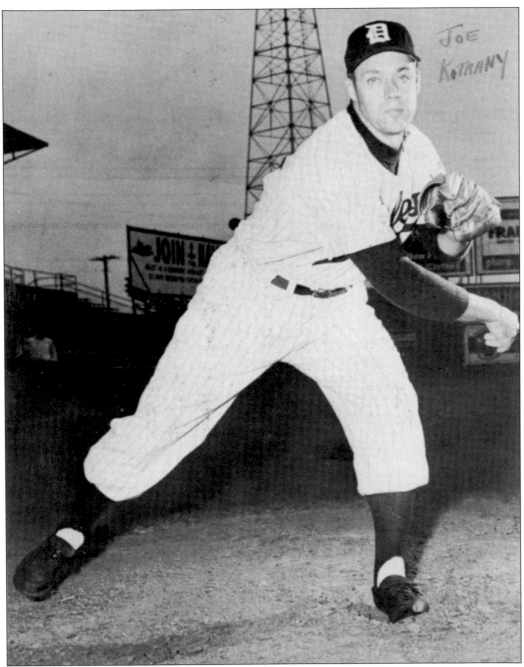

Pitcher Joe Kotrany, a native of Cleveland who began his pro career in 1947, first became familiar to Dallas fans when he played for Texas League opponent Oklahoma City in 1950. After spending the 1951 season with Wichita in the Cleveland Indians farm system, he was assigned to the Eagles for 1952. Kotrany would go on to spend eight seasons in a Dallas uniform, winning a total of 84 games before retiring from the game in 1959. His best season came in 1958, when he was named Texas League Pitcher of the Year with a 19-10 record and a 2.99 ERA.

Eddie Knoblauch was a fixture in the Texas League for more than a decade. The speedy outfielder, who began his baseball career in 1938 in the St. Louis Cardinals massive farm system, first came to the Texas League when assigned to the Houston Buffaloes in 1942. Knoblauch lost three seasons due to military service, but he returned to Houston in 1946. In 1951, he joined Dallas for the first time and he would spend all or part of the next five seasons with the Eagles. When he retired from the playing field after the 1955 season, Knoblauch had amassed more than 2,500 hits, scored over 1,400 runs and had a career batting average of .313. In his final season, at age 37, he won the Texas League batting title with a .327 average and led the league with 48 doubles. Baseball skill apparently ran in the Knoblauch family; Eddie Knoblauch's nephew, Chuck, went on to become an American League All-Star infielder in the 1990s.

Dallas native Jodie Beeler signed his first professional baseball contract with Lamesa of the West Texas New Mexico League in 1940, went on to have standout seasons with Birmingham and Syracuse, and even got a brief call-up to the major leagues with Cincinnati. In 1951, his career brought him back to Dallas when he signed for the Eagles. For three and a half seasons, Beeler's ability to play several different positions made him an invaluable member of the team and he contributed greatly to the Eagles' first place finishes in 1952 and '53. He finished his career as a playing manager with several Texas teams, including Wichita Falls.

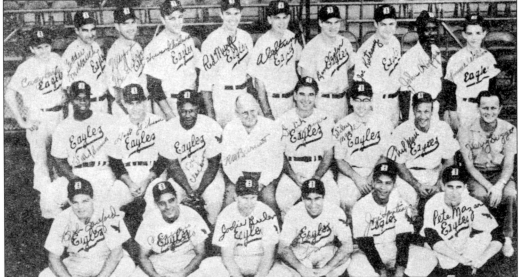

Guided by manager L.D. "Dutch" Meyer (middle row, fourth from right), the 1953 Dallas Eagles won the Texas League pennant and went on to a Dixie Series victory over Southern Association champ, Nashville. Meyer had been a star football player at TCU where he helped lead the school to a national championship in 1935 as well as a Cotton Bowl win in 1937. Also a talented baseball player, Meyer spent parts of several seasons in the big leagues with Detroit and Cleveland. He later played a couple of seasons with Gladewater, where, as player-manager, he won a batting title and led the team to the East Texas League pennant in 1950. The Gladewater club happened to be owned by Dallas owner Dick Burnett (middle row, center), and in 1951 Burnett hired Meyer to guide his Eagles. In all, Meyer spent four seasons at the helm of the club.

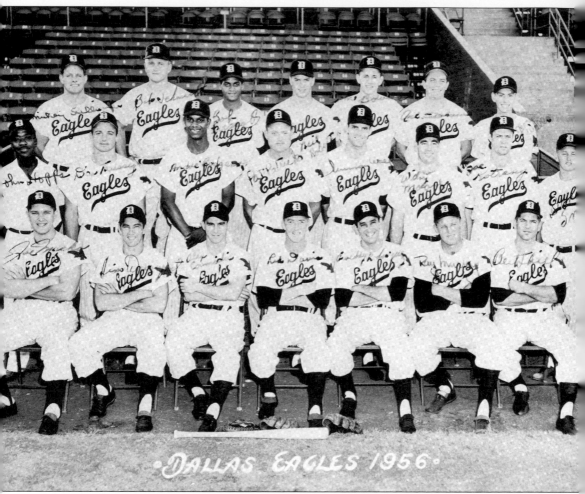

Thanks to a strong pitching staff, the 1956 Eagles finished second in the Texas League with a 94-60 record. They swept Fort Worth in the opening round of the playoffs but lost to pennant-winning Houston, four games to one, in the finals. From left to right: (front row) Joe Macko, Jim Davenport, Alex Cosmidis, John "Red" Davis (manager), Freddy Rodriguez, Ray Murray, and Bert Thiel; (middle row) John Hopps (trainer), Don Taussig, Andre Rodgers, Pat Patrick, Murray Wall, Wilcy Moore, Joe Kotrany, and ? Smith (bat boy); (back row) Mickey Sullivan, Bob Schmidt, Bob Prescott, Neil Roberts, Tom Bowers, Art Dunham, and Jerry Walls (bat boy).

Always looking for new ways to make an evening at the ballpark more fun for the fans, Dick Burnett hired Inez Teddlie to be the team's organist in 1949. For 15 years, she played for the fans from her seat behind home plate, performing classics such as "Take Me Out to the Ballgame" as well as the Eagles' theme song, "Under the Double Eagle March." Players who hit home runs would circle the bases to the tune of "Waitin' for the Robert E. Lee." The opening words of that song are "Way over the levee" and the Trinity River levee was just beyond the outfield fence. "Miss Inez", as she was known to fans, also served as organist for the Dallas Chaparrals basketball team and the Dallas Blackhawks hockey team. She was very active in the Dallas music scene until her death in 2002 at age 91. (Courtesy Pat Freudiger.)

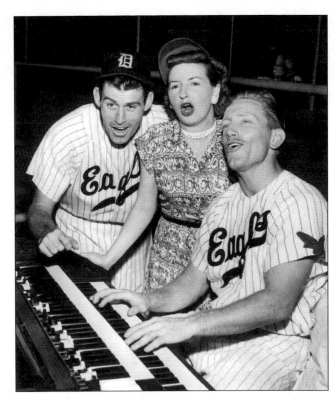

Wilcy Moore, a native of Muleshoe, Texas, was the Dallas left fielder from 1952 through 1957. He first joined the Eagles when he was purchased from Longview to strengthen the team during the pennant drive. A strong defensive player with a great arm, Moore also produced at the plate and had his best season in 1957, when he batted .308 and drove in 81 runs. His well-known uncle, also named Wilcy Moore, had played in the Texas League with Fort Worth and Oklahoma City before spending six years in the big leagues and winning 19 games for the legendary 1927 New York Yankees. (Courtesy of the Texas/Dallas History and Archives Division, Dallas Public Library.)

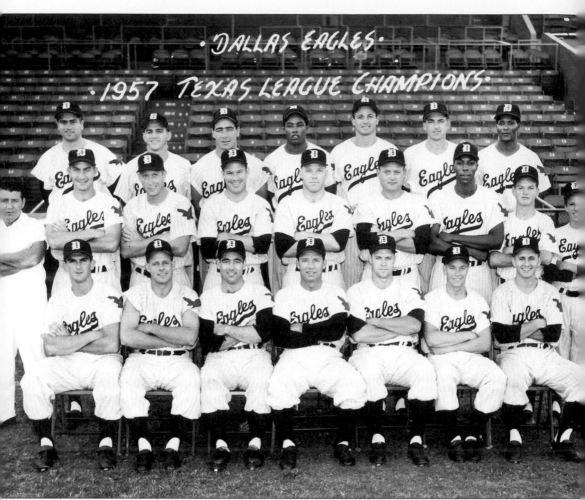

The 1957 Dallas Eagles were one of the best teams to ever represent the city. Guided by manager Salty Parker (front row, center) and featuring 19-year-old first baseman Willie McCovey (middle row, third from right) and veteran second baseman Alex Cosmidis (back row, second from left) the team cruised to a 102-52 record. Houston, with 97 wins, also had a good team that season, and in the playoff finals the Buffaloes defeated the Eagles, four game to three, in a thrilling series. After a long major league career, Willie McCovey was enshrined in the baseball Hall of Fame in 1985, the only former Dallas Eagle to be so honored.

The baseball career of Francis "Salty" Parker that began in 1930 lasted more than 40 years. As a talented shortstop he made it up to the Detroit Tigers for a few games at the end of the 1936 season, but it was back to the minors the following year. In 1939, he signed with Dallas, but played only 13 games before securing his release to take a playing manager job with Lubbock in the West Texas-New Mexico League. Over the next decade Parker became a familiar face in Texas minor league baseball as he played for and managed in such towns as Marshall, Temple and Tyler. He was probably most familiar to Texas League fans, however, as he skippered Shreveport's entry in that league for eight seasons. In 1957, Parker returned to Dallas and guided the Eagles to an impressive 102-52 record and the regular season title. He became a coach with the Eagles' big league parent club, the San Francisco Giants, the next season and eventually spent 16 seasons coaching in the major leagues with seven different clubs and served as a temporary manager for both the Mets and the Astros.

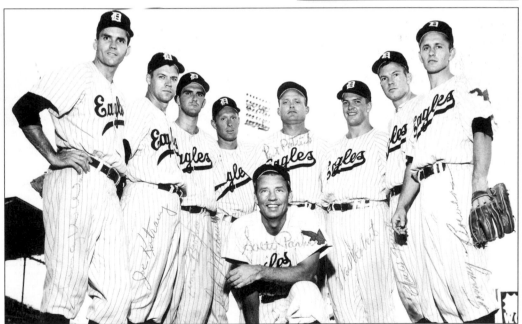

Manager Salty Parker (kneeling) poses with his potent pitching staff in 1957. From left to right are Murray Wall (16-7, 1.79 ERA), Joe Kotrany (12-10, 2.58 ERA), Ernie Broglio (17-6), Dick Maibauer (10-7), Pat Patrick (5-3, 2.77 ERA), Neil Roberts (4-1), Charlie Fowler (13-5), and Tommy Bowers (20-8), who was named Texas League Pitcher of the Year. Wall, a Dallas native, would join the Boston Red Sox that September and spend the next two seasons in the big leagues. Broglio would be a 20-game winner for the St. Louis Cardinals in 1960.

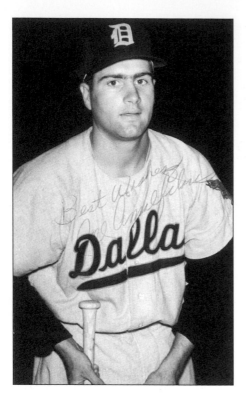

Joe Amalfitano signed with the Giants as a 20-year-old "bonus baby" in 1954, a move that required him to be placed on the big league roster. Not ready for big league pitching the young infielder only saw action in a few games and in 1956 the Giants were allowed to send him down to the minor leagues to gain experience. For the 1957 season Amalfitano was assigned to Dallas where he batted a respectable .292. He made it back to the Giants in 1960 as a utility player, and in 1961 he was selected in the expansion draft by the Houston Colt .45s. In all Amalfitano spent parts of ten seasons in the big leagues. After his playing career he was a longtime big league coach with several teams and manager of the Chicago Cubs from 1979 to 1981.

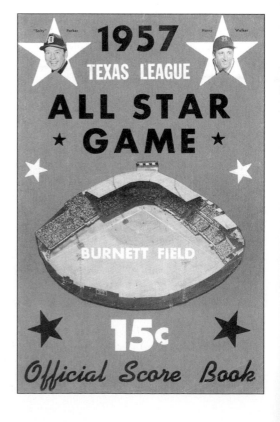

In 1957, the Texas League All-Star Game was held in Dallas at Burnett Field. The game saw the Eagles take on a team composed of the top players from other league members. Managed by Houston skipper Harry Walker, the All-Star roster included future big leaguers Ruben Amaro (Houston), Eddie Haas (Fort Worth), and Frank Baumann (Oklahoma City). The All-Stars prevailed in the game, 5-3.

THREE

The Dallas-
Fort Worth Years

Dick Burnett had long believed that the Dallas-Fort Worth area could support a major league team, a dream that was shared by the Dallas franchise's new owners, J. W. Bateson and Amon Carter, Jr. In 1959, their Dallas club (renamed the Rangers) left the Texas League and moved one step closer to the major leagues by joining the Class AAA American Association. The Rangers weren't the only charter member of the Texas League to jump ship; the Houston and Fort Worth clubs also joined the American Association that season

In the late 1950s, there was growing frustration as the major leagues resisted the calls for expansion by several growing markets, including Dallas-Fort Worth and Houston. This led to a movement by Branch Rickey to organize a rival "major" league, the Continental League. Area baseball leaders felt Dallas and Fort Worth would be better served if only one franchise from the area joined this new league. This led to a merging of the Dallas and Fort Worth minor league teams for the 1960 season. Playing in the American Association, the Dallas-Fort Worth Rangers split their home schedule between Burnett Field in Dallas and LaGrave Field in Fort Worth.

Hoping to avoid competition from the proposed Continental League, the major leagues finally decided to expand, but Dallas-Fort Worth was not awarded a franchise (though Houston was). With the Continental League dead, Bateson and Carter decided to continue as a merged minor league entry. After the 1962 season the American Association disbanded and the D-FW Rangers joined the Pacific Coast League for 1963. In 1964, Fort Worth businessman Tommy Mercer and Lamar Hunt bought the D-FW franchise and once again split it into two clubs. He kept Dallas in the PCL and returned Fort Worth to the Texas League. This experiment only lasted one year, and the teams would reunite for the 1965 season.

The new Texas League entry, now named the Dallas-Fort Worth Spurs, played in Arlington, Texas. For the first time professional baseball was not played in either Dallas or Fort Worth. A new ballpark, Turnpike Stadium, was constructed between the two cities near the Six Flags theme park in Arlington.

Several other attempts were made during the 1960s to bring major league baseball to the Dallas area. In 1962, Charlie Finley proposed to move his Kansas City Athletics to the DFW Metroplex. The plan was eventually rejected by other American League owners, but they did recognize having a big league team in the Dallas area was an eventual possibility. Six years later

it was the National League that rejected Dallas-Fort Worth as a site for a team when it granted new expansion franchises to Montreal and San Diego.

Despite failures, dreams of major league baseball finally came true when Arlington mayor Tom Vandergriff and others convinced a major league team to relocate. On September 20, 1971, Robert Short, owner of the Washington Senators received approval from the other American League owners to move his ball club to Arlington for the 1972 season. The final consenting vote came from colorful Oakland A's owner Charles Finley, who had held out his vote trying to pry Senators rookie Jeff Burroughs from Washington in exchange for his favorable vote.

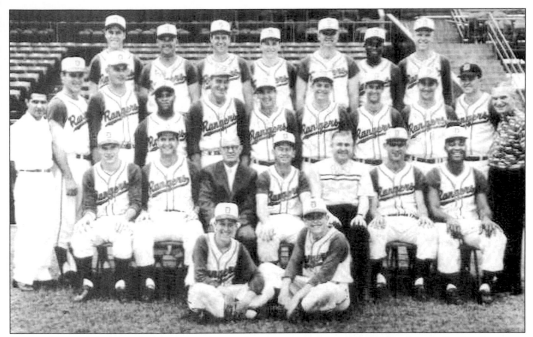

In a tribute to the state's legendary law enforcement agency, the Dallas baseball club became known as the Rangers in 1958. Managed for much of the season by former New York Giants second baseman Davey Williams, a native of Dallas, the team finished only fifth in the Texas League standings with a record of 76-77.

Speedy second baseman Frank Murray spent several seasons playing professional baseball in California before making his way east in the early 1950s to play for Amarillo and then Wichita Falls. In 1954, he signed with Oklahoma City in the Texas League and remained with that club until joining the Dallas Eagles in the middle of the 1955 season. Murray played a few games with the Eagles the following season before being sent to Amarillo, where his .323 batting average helped the Gold Sox finish on top of the Western League (at one point during that season he hit 11 triples in ten games). In 1958, Murray returned to Dallas for one final season before retiring from the playing field and making his permanent home in the city.

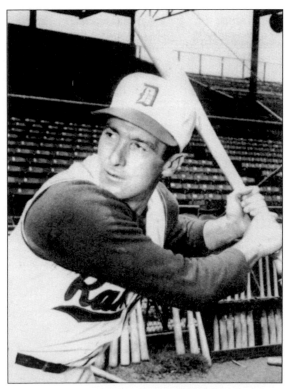

A new era began in Dallas baseball history in 1960 when a single team was formed to represent both Dallas and Fort Worth. It was a rather inauspicious beginning for the single-team idea as the D-FW Rangers finished last in the American Association with a 64-90 record. Partially due to the team's poor performance on the field, attendance for the season was also disappointingly low as the team drew only 113,849 fans. The previous season had seen 130,334 pass through the turnstiles in Dallas while Fort Worth drew 97,315 fans by itself.

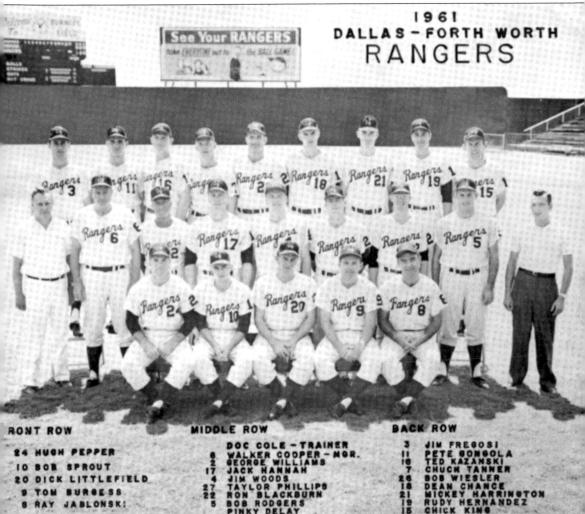

FRONT ROW

24 HUGH PEPPER
10 BOB SPROUT
20 DICK LITTLEFIELD
9 TOM BURGESS
8 RAY JABLONSKI

MIDDLE ROW

DOC COLE - TRAINER
6 WALKER COOPER - MGR.
2 GEORGE WILLIAMS
17 JACK HANNAH
4 JIM WOODS
27 TAYLOR PHILLIPS
22 RON BLACKBURN
5 BOB RODGERS
PINKY DELAY

BACK ROW

3 JIM FREGOSI
11 PETE GONGOLA
16 TED KAZANSKI
7 CHUCK TANNER
26 BOB WIESLER
18 DEAN CHANCE
21 MICKEY HARRINGTON
19 RUDY HERNANDEZ
15 CHICK KING

In 1961, the second year a single team represented both Dallas and Fort Worth, the D-FW Rangers finished fifth in the AAA American Association with a record of 72-77. The top farm club of the expansion Los Angeles Angels, the Rangers were guided by former big league catcher Walker Cooper. The lineup that season featured catcher Bob Rodgers (.286), pitcher Jack Spring and shortstop Jim Fregosi (.254), all of whom received September call-ups to Los Angeles. Fregosi returned to the Rangers in 1962 for part of a season before winning a permanent job and becoming a six-time All-Star in the big leagues. In 1973, he returned to the Dallas-Fort Worth area to play for the big league Rangers. Fregosi spent much of five seasons with the club before being traded to Pittsburgh in 1977.

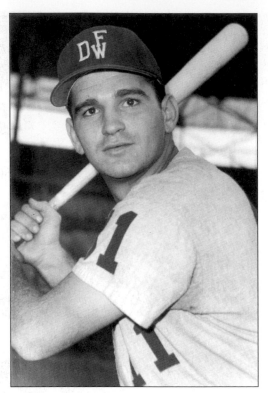

The minor league career of West Virginia native Pete Gongola took him from Georgia to North Dakota to Washington State to Mexico, with a few other stops as well. He spent the 1961 and '62 seasons with Dallas-Fort Worth. Career minor leaguers such as Gongola were a rare breed by the mid-1960s. In an attempt to remain financially solvent, minor league clubs became dependant upon major league affiliates to support them. As a result, the primary purpose of minor league clubs became the development of young talent. As big league parent clubs wanted their minor league affiliates to give their young prospects playing time, it left little room on rosters for long time veterans and former big leaguers.

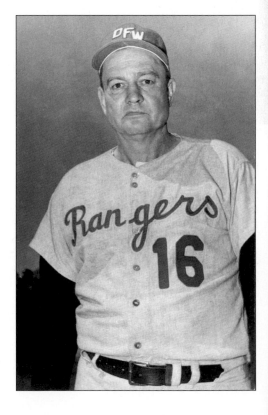

Walker Cooper, who had played in Dallas as a member of the visiting Houston Buffs in the late 1930s before going on to big league stardom, took over the reins of the Dallas-Fort Worth Rangers in 1961. Cooper's one year with the club wasn't a successful one, however, as the Rangers finished fifth in the six-team American Association with a 77-77 record.

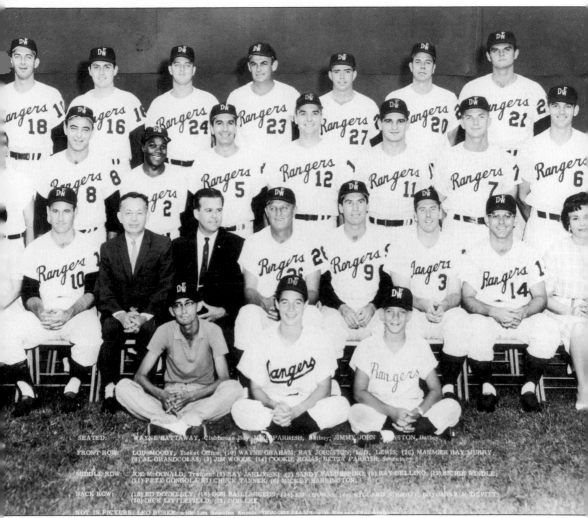

The 1962 Dallas-Fort Worth Rangers operated as a co-op with players supplied by both the Los Angeles Angels and the Philadelphia Phillies. Though the team featured several notable players including infielder Cookie Rojas, a future big league All-Star, and outfielder Chuck Tanner, who as manager would lead Pittsburgh to a World Series title in 1979, the Rangers finished in the American Association cellar with a 59-90 record. Another player of note on that season's team was outfielder Wayne Graham, who, after two brief trials in the major leagues, turned to coaching. In 2003, he led Rice University to the NCAA Division I baseball title. Players and staff, from left to right: (front row) Wayne Hattaway (cluhouse boy), Mike Parrish (batboy), and Jimmy Johnston (batboy); (second row) Lou Moody (ticket office), Wayne Graham, Ray Johnston, L. D. Lewis, Ray Murry (manager), Al Grandcolas, Jim Woods, Cookie Rojas, and Betty Parrish (secretary); (third row) Joe McDonald (trainer), Ray Jablonski, Sandy Valdespino, Ray Bellino, Richie Windle, Pete Gongola, Chuck Tanner, Mickey Harrington; (back row) Ed Donnelly, Bob Baillargeon, Ed Thomas, Willard Schmidt, Danny McDevitt, Dick Littlefield, and Bob Lee.

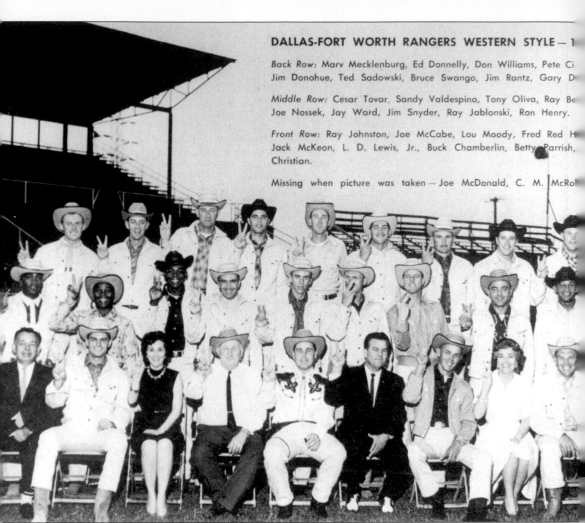

In 1963, the Dallas-Fort Worth Rangers players and staff posed for a "western style" team portrait. From left to right: (front row) Ray Johnston, Joe McCabe, Lou Moody, Fred "Red" Harris, Jack McKeon (manager), L.D. Lewis, Jr., Buck Chamberlin, Betty Parrish, and Jow Christian; (middle row) Cesar Tovar, Sandy Valdespino, Tony Oliva, Ray Bellino, Joe Nassek, Jay Ward, Jim Snyder, Ray Jablonski, and Ron Henry; (back row) Marv Mecklenburg, Ed Donnelly, Don Williams, Pete Cimino, Jim Donohue, Ted Sadowski, Bruce Swango, Jim Rantz, and Gary Dotter. Tony Oliva, the team's offensive star that season, batted .304 with 23 home runs on his way to a career that may land him in the Hall of Fame. Infielder Cesar Tovar (.297, 115 runs) also went on to be standout in the big leagues, while skipper Jack McKeon, whose managerial career began in 1955, would lead the Florida Marlins to a World Series title in 2003.

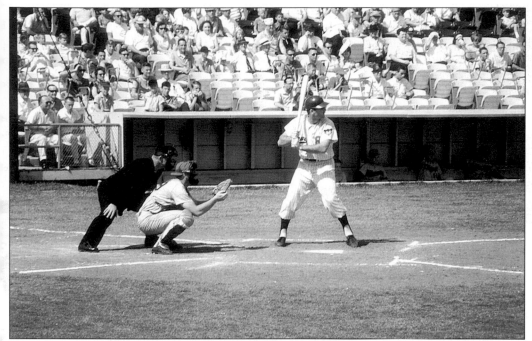

An unidentified Dallas-Fort Worth batter waits for the pitch in a game against the Albuquerque Dodgers at brand new Turnpike Stadium in 1965. For three seasons (1965–1967) the Spurs were the Texas League farm club of the Chicago Cubs, hence the Cubs logo on their jersey. The Spurs ended the 1965 season with an 80-60 record, tied with Tulsa for first in the East division of the league. The two teams then faced each other in a one-game playoff, which Tulsa won, 2-0.

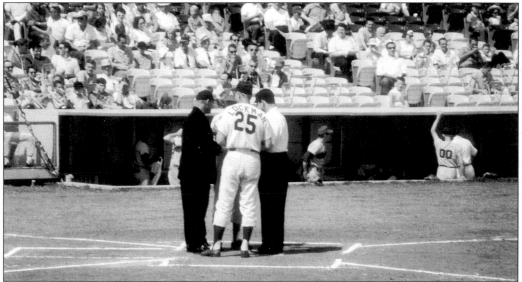

Manager Whitey Lockman, seen here in discussion with umpires during a 1965 game, had a 15-year big league playing career. In his one season at the helm of the Spurs, he guided the team to an 80-61 record, an accomplishment that won him Texas League Manager of the Year honors. He moved up in the Cubs organization the next season to take a coaching job in Chicago and eventually managed the team from 1972 to 1974.

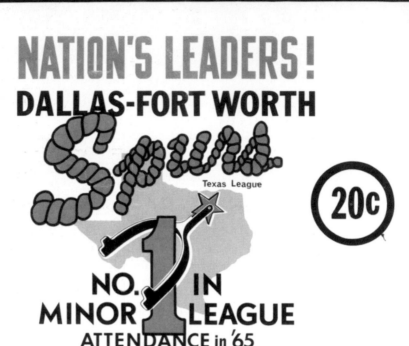

The DFW Spurs led all of minor league baseball in attendance in 1965 as they drew 329, 294 to Turnpike Stadium, an accomplishment the club was very proud of as evidenced by this 1966 program cover. This success fueled the belief that the Dallas-Fort Worth area was ready for major league baseball.

San Antonio native Fred Norman had already made a few brief appearances in the major leagues when the Cubs sent him to join the Spurs late in the 1965 season. He was winless in four games but returned the following year to dominate Texas League hitters. Norman won 12 games that season, had an ERA of 2.72, and led the league with 198 strikeouts and was named Texas League Pitcher of the year. He was called back up the join the Cubs, but it wasn't until being traded to the Cincinnati Reds that Norman stuck in the big leagues. A key part of the Reds' "Big Red Machine" of the mid-1970s, Norman would win 104 games in a big-league career that lasted through 1980.

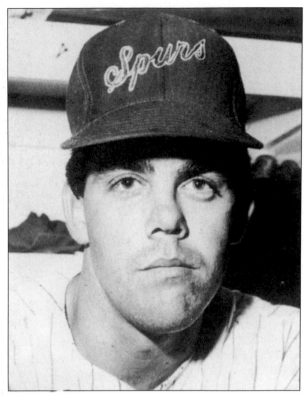

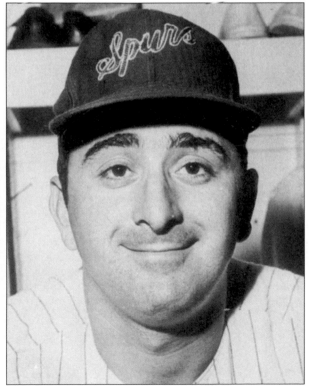

Relief pitcher Len Church first joined the D-FW Spurs in 1965, but appeared in only a few games. Returning in 1966, he pitched well with a 6-4 record and a 2.90 ERA. Church's strong performance earned him a late-August call-up to Chicago and he appeared in four games. He never made it back to the big leagues, but he did spend several more seasons with Tacoma of the Pacific Coast League, the Cubs' highest minor league affiliate.

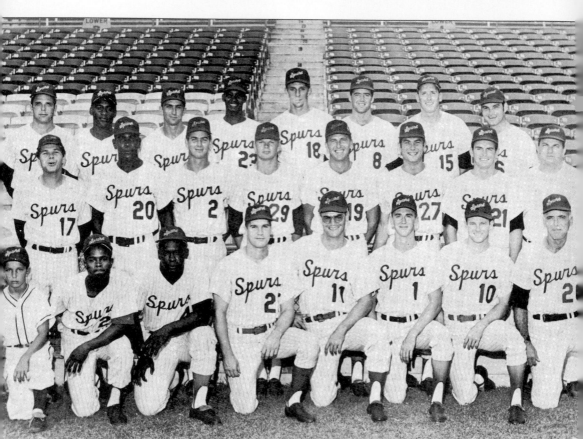

Front Row: Steve Macko, Brock Davis, Hal King, Gene Etter, Arnie Umbach, Fred Stanley, Lee Bales, and Hub Kittle.
Second Row: Luis Penalver, Rafael Batista, George Gerberman, Roy Shrawder, Fred Walters, Ernie Foli, Paul Doyle, Sam Wilki
Back Row: Tom Fullen, Glen Clark, Rick Pierini, Secundino Almonte, Wayne Twitchell, Ron Crook, Brian Murphy, Larry How

1968 DALLAS-FT. WORTH SPURS

Though the 1968 Dallas-Fort Worth Spurs led the Texas League in attendance by nearly 75,000 fans, the team didn't find much success on the field and finished last in the league's East division with a 60-79 record. Perhaps the most interesting member of that season's team was actually one of the batboys, Steve Macko. The son of general manager and former Dallas player Joe Macko, Steve displayed some of his father's baseball talents at an early age. At Bishop Dunne High School in Dallas he led his team to a state title as a sophomore and earned All-Texas honors as a senior. After a stellar senior season at Baylor University in which he was named as a first team All-American at shortstop, Steve was selected in the fifth round of the 1977 draft by the Chicago Cubs. In 1979, he made his big league debut and appeared to be on his way to a starting job. Tragically, Steve Macko was diagnosed with testicular cancer in 1980 and died the following year at the age of 27. The 1968 Spurs, from left to right, are (front row) Steve Macko (batboy), Brock Davis, Hal King, Gene Etter, Arnie Umbach, Fred Stanley, Lee Bales, and Hub Kittle (manager); (middle row) Luis Penalver, Rafael Batista, George Gerberman, Roy Shrawder, Fred Walters, Ernie Foli, Paul Doyle, and Sam Wilkinson; (back row) Tom Fullen, Glen Clark, Rick Pierini, Secundino Almonte, Wayne Twitchell, Ron Crook, Brian Murphy, and Larry Howard.

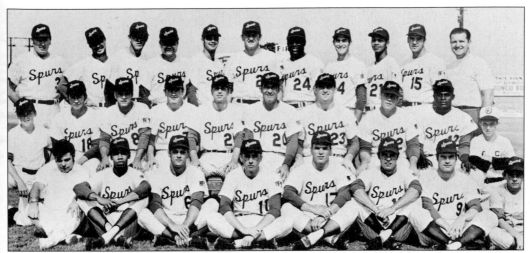

In 1969, the Dallas-Fort Worth Spurs were much improved over the previous season's team. After changing major league affiliation from Houston to the Baltimore Orioles, the team had a new manager, Joe Altobelli, and a whole new line-up. Led by batting champ Larry Johnson (.337) and MVP Bobby Grich (.310), the Spurs finished second in the Texas League's West division with a 75-58 record. Altobelli, who won Manager of the Year honors, would go on to guide Baltimore to a World Series title in 1983. Outfielder Don Baylor would also become a successful big league manager after a long career as a standout player. Probably the most significant member of the team, however, was catcher Johnny Oates. After a solid big league career, Oates, like Altobelli, would manage the Orioles. In 1995, he returned to the Dallas-Fort Worth area to take over as manager of the Rangers.

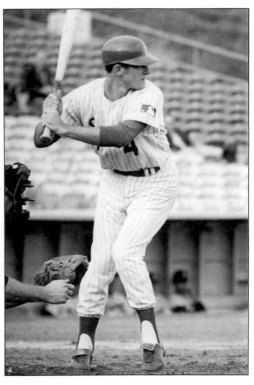

In 1967, the Baltimore Orioles selected high school star Bobby Grich in the first round of the draft. A smooth-fielding middle infielder with a potent bat, Grich worked his way up the Orioles chain and was assigned to Dallas-Fort Worth in 1969. He had an outstanding season with the Spurs, batting .310, and he shared league MVP honors with teammate Larry Johnson. Promoted the next season, Grich was named Minor League Player of the Year with Rochester in 1971, and by 1972 he was starting for the Orioles. During his 15-year big league career with the Orioles and the California Angels, Grich won four Gold Glove awards and was named to six All-Star teams. He retired after the 1986 season with 224 home runs and a career batting average of .266.

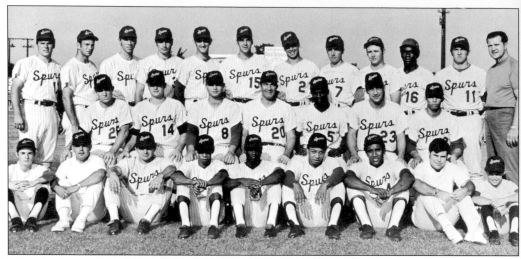

Though they led the Texas League in attendance, the 1970 Dallas-Fort Worth Spurs could do no better than third in the league's Western division with a 63-73 record. From left to right, are (front row) Cary Phillips (bat boy), Bill Milkie (equipment manager), Chris Carnegie, Stan Martin, Rich Coggins, Lew Beasley, Petey Watts, Ron Rouden (trainer), and Brent Kinman (bat boy); (middle row) Ron Shelton, Scott McDonald, Jim Kelly, Joe Altobelli (manager), Cliff Matthews, Ralph Manfredi, Enzo Hernandez; back row: Randy Cohen, Dyar Miller, Terry, Wilshusen, George Manz, Mike Hersan, Carroll Maulden, Greg Arnold, Rich Thoms, Jeff Williamson, Steve Green, Wayne Garland, and Joe Macko (general manager).

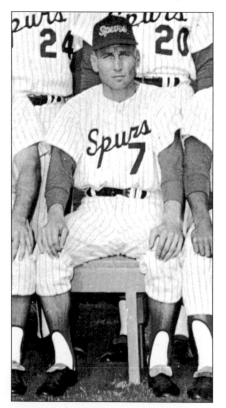

The 1971 Dallas-Fort Worth Spurs, the last minor league team to represent area for 30 years, were managed by Cal Ripken, Sr. With a squad that included future big leaguers Doug DeCinces, Enos Cabell and Junior Kennedy, the veteran skipper steered his team to a second place finish in the Texas League's Western division. Ripken would go on to spend many seasons as either coach or manager with the Baltimore Orioles. His son Cal Jr. would have a legendary playing career with the Orioles while his son Billy would spend the 1993, '94, and '97 seasons as an infielder with the Texas Rangers.

FOUR

The Rangers

In November of 1971, Robert Short announced that his Washington Senators team would be renamed the Rangers when it relocated to Texas. There was great excitement that major league baseball was finally coming to the Dallas area, but in all honesty the team moving to Arlington was not one of the premier franchises in baseball. The Senators had finished with the second-worst record in the American League for two consecutive seasons, and in 1971 they lost 96 games and trailed the first place Orioles by 38 1/2 games. Still, the club was managed by the legendary Ted Williams, and did it feature powerful first baseman Frank Howard, one of the top sluggers in the game.

A players' strike, the first by the new players union, postponed the Rangers' first game by two weeks, but on April 15, 1972, the Rangers era officially began. The team dropped its first game on the road to the Angels, 1-0, but catcher Hal King singled for the first base hit in team history. The Rangers first win at home came six days later as Frank Howard homered and the Rangers topped the Angels before a crowd of 20,105 at Arlington Stadium.

The Rangers struggled for their first two seasons. There has even been speculation that one sellout game in 1973, when owner Robert Short put Texas high school phenom David Clyde on the mound, saved the club from financial ruin. In 1974, led by fiery manager Billy Martin, the Rangers generated excitement. In the playoff race for nearly all of the season, the team eventually finished second with an 84-76 record, five games behind eventual World Series champion Oakland. Outfielder Jeff Burroughs was AL MVP, first baseman Mike Hargrove was AL Rookie of the Year, and pitcher Ferguson Jenkins finished second in voting for the Cy Young Award.

Though the team showed great promise in 1974, the Rangers consistently fell short in their bid to reach the playoffs, finishing second in 1977, 1978 and 1981. In May of 1985, Bobby Valentine took over as manager and he guided the Rangers to yet another second place finish in 1986. It would be the team's best finish in his nearly eight seasons at the helm

Despite the failure to reach the playoffs, the Rangers line-up included some of the biggest names in the game during the late 1980s and 1990s. Veteran star pitcher Nolan Ryan joined the team in 1989. With the Rangers he pitched his sixth and seventh no-hitters and passed the 5,000 mark in strikeouts. Though long considered a star, Ryan achieved legend status with the Rangers. In the early 1990s, the quartet of Julio Franco, Rafael Palmeiro, Juan Gonzalez and Ruben Sierra gave the Rangers one of the most potent offenses in the major leagues.

Kevin Kennedy replaced Bobby Valentine as manager in 1993 and he guided the team to a second place finish (86-76) his first season. In 1994, despite a losing 52-62 record, the Rangers were in first place before a player strike ended the season and denied the Rangers what could gave been their first divisional title.

In 1996, second-year manager Johnny Oates, who had played for the 1969 D-FW Spurs, steered the Rangers to a first place finish in the American League's West division. Despite losing to the New York Yankees in the playoffs, it was the most successful season in club history. Oates became the first Texas manager to win the AL Manager of the Year Award while outfielder Juan Gonzalez was the second Ranger to be named AL MVP. The Rangers went on to win two more divisional titles during Oates' tenure, and the 1999 team set a franchise record with 95 wins. Each season, however, the team failed to get past the Yankees in the playoffs.

A group headed by financier Thomas Hicks purchased the Rangers in January of 1998 for $250 million. Also the owner of the Dallas Stars hockey team, Hicks invested heavily in the Rangers. In 2000, he signed free agent shortstop Alex Rodriguez, generally regarded as the best player in the game, to a massive 10-year, $252 million contract. After four straight last place finishes in the AL West, Hicks and general manager John Hart began to build a new, younger team in 2004. Gone were sluggers Rafael Palmeiro and Juan Gonzalez and MVP catcher Ivan Rodriguez. Instead the team's focus shifted to a group of young players that included Mark Teixeira, Hank Blalock, and Michael Young.

TEXAS RangerS

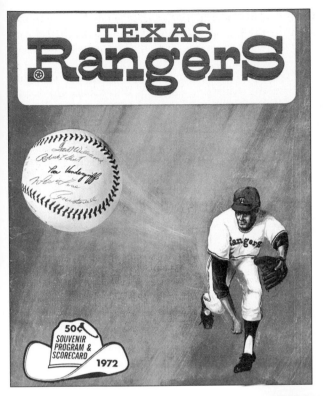

50¢ SOUVENIR PROGRAM & SCORECARD 1972

Though there was much initial excitement about the arrival of major league baseball in the Dallas-Fort Worth area, the Rangers lack of success on the field and quick drop to the divisional cellar brought about a lack of interest by the fans. In the end, the team finished $38^1/_2$ games out of first with a total attendance of 662,974, an average of just 8,840 and only slightly better than the team had drawn in Washington the previous season. By comparison, the Rangers drew an average of better than 30,000 fans per game throughout the 1990s.

The legendary Ted Williams, one of the greatest players in the history of the game, served as the first manager of the Texas Rangers. Hired to manage the lowly Washington Senators in 1969, the "Splendid Splinter" accompanied the franchise when it moved to Arlington in 1972. In Williams' one season at the helm of the Rangers, his last in baseball, the team finished with a 54-100 record. He retired on September 30 and was replaced as Rangers manager by Whitey Herzog, director of player development for the New York Mets.

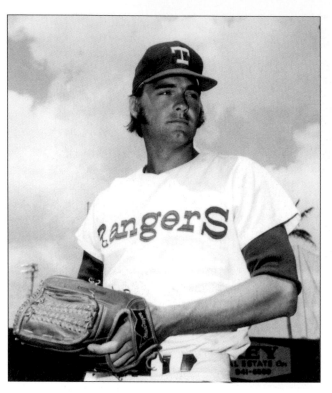

On April 16, 1972, right-hander Pete Broberg beat the California Angels, 5-1, for the first victory in Texas Rangers history. Drafted by the Senators in 1971 after a stellar career at Dartmouth College, Broberg was ordered to report directly to Washington by the pitching-starved franchise. He made his big league debut on June 20 of that season, becoming one of the very few players to never appear in the minor leagues on his way up. The rush to the major leagues probably hurt the talented Broberg's development as a pitcher, however. He won only five games with Washington and ten more in three seasons after the club moved to Texas. In December of 1974, the Rangers traded Broberg to the Milwaukee Brewers for veteran pitcher Clyde Wright.

In the 1973 amateur draft, the Rangers had the number one overall pick. Their selection was a fireballing lefthander out of Houston's Westchester High School named David Clyde. The selection of the charismatic and immensely talented phenom brought much media hype, and Rangers' ownership decided to send him to the mound only days after his high school graduation. Before a huge crowd, Clyde won his big league debut, but it was soon apparent that he was not ready for the big leagues. He won a total of only seven games over three seasons before being traded to Cleveland. With the Indians, Clyde won eight games in 1978, but injuries limited him to only three wins the following season. In 1980, he was traded back to the Rangers as part of a multi-player deal. He failed to make the team, however, and was given his release at the end of Spring Training. The career that had once seemed so promising was over at age 26. The opinion of many is that Clyde, his career hurt by the rush to the major leagues, was essentially used as a pawn in a plan to boost attendance and make the Rangers franchise more attractive to potential buyers.

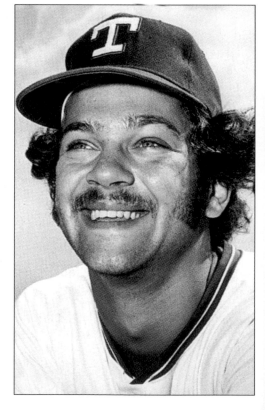

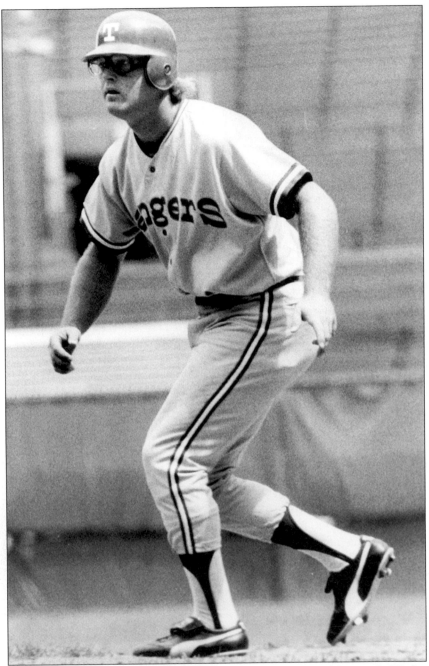

Former number one draft pick Jeff Burroughs made his big league debut with Washington in 1970 as a teenager, and by 1973 he had won a starting outfield job with the relocated club. In 1974, at the age of only 23, Burroughs had an outstanding season (.301, 118 RBIs, 25 home runs, 84 runs) and won the American League MVP Award as he led the Rangers to a second place finish. Unfortunately, that proved to be his best season in Texas and he was traded to Atlanta in 1977 for five players and cash. Though he never achieved the super-stardom many predicted for him, Burroughs had a very solid major league career and retired after the 1985 season with a lifetime .261 batting average and 240 home runs.

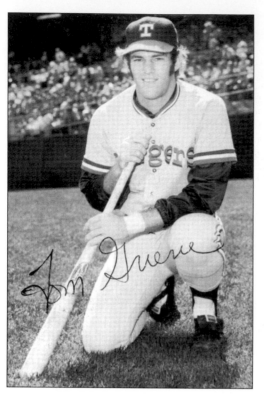

Tom Grieve has worn several different hats with the Texas Rangers organization. A member of the first Rangers team, he played a total of six seasons with the club as an outfielder. He was eventually traded to the New York Mets as part of four-team deal in December of 1977 that brought Al Oliver, Nelson Norman and Jon Matlack to Texas. After his playing days were over, Grieve pursued a new career in the front office and in 1984 he was named as the Rangers general manager. He held that position through the 1994 season. In 1995, Grieve became a television announcer for the team.

In the fall of 1973, the Rangers acquired right-hander Ferguson Jenkins from the Chicago Cubs in exchange for infielders Bill Madlock and Vic Harris. Though a six-time 20-game winner for the Cubs, Jenkins had not pitched particularly well in 1973. The Rangers were proven correct in their belief that Jenkins still had something left in his arm, and with a 25-12 record, a 2.82 ERA, 225 strikeouts, and 29 complete games, he had the best season any Rangers pitcher has ever had. He won 17 games the following season before being traded to the Boston Red Sox. In 1978, Jenkins was back in a Rangers uniform and he again had an outstanding season, winning 18 while loosing only eight. He pitched for Texas through the 1981 season before returning to the Cubs and retiring in 1983. In 1991, Jenkins was inducted into the National Baseball Hall of Fame.

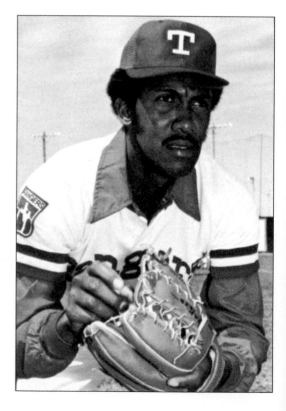

Powerful right-handed pitcher Jim Bibby broke in to the major leagues with the Cardinals at the end of the 1972 season. The following June he was traded to the Rangers and immediately placed in the starting rotation. Bibby won nine games that first season in Texas and on July 30 he threw the first no-hitter in team history by blanking the Oakland A's, 6-0. The next year he won 19 games, but early in the 1975 season he was traded to Cleveland (with Jackie Brown and Rick Waits) for Gaylord Perry. After a World Series title and an All-Star appearance with the Pirates, Bibby returned to the Rangers briefly as a free agent in 1984 before retiring from the game.

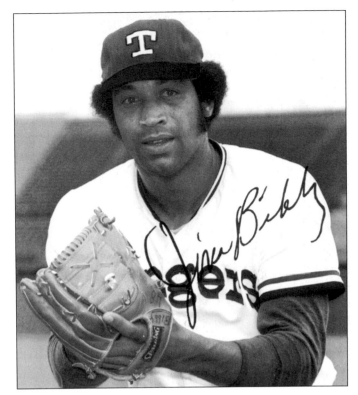

Former New York Yankees infielder and Detroit Tigers skipper Billy Martin took over as manager of the Rangers on September 8, 1973, replacing Whitey Herzog, Martin quickly turned the last-place team around and 1974 Rangers won 27 games more than they had the previous season and finished in second place. In 1975, with the team's record standing at 44-51, Martin was fired by the Rangers on July 21 and replaced by third base coach Frank Lucchesi. Martin immediately found a job managing the Yankees and he led that club to back-to-back Word Series titles in 1977 and '78.

In the 25th round of the 1972 draft the Rangers selected unheralded infielder Mike Hargrove, a native of Perryton, Texas, out of Northwestern Oklahoma State University. It proved to be a brilliant move as Hargrove won the 1974 American League Rookie of the Year award with a .323 batting average. He would follow that up with a spot on the AL All-Star team in 1975. In all, Hargrove spent five standout seasons in a Rangers uniform. After the 1978 season he was traded, along with utilityman Kurt Bevaqua and back-up catcher Bill Fahey, to the San Diego Padres for Oscar Gamble, Dave Roberts and cash. Hargrove retired in 1985 after spending six and a half seasons with the Cleveland Indians, a team he would later go on to manage.

Gaylord Perry, the 1972 American League Cy Young Award winner, was traded by the Cleveland Indians to the Rangers in exchange for Jim Bibby, Jackie Brown, Rick Waits and $125,000 cash on June 13, 1975. Perry won 12 games for the Rangers in his first season and 15 in each of the next two. In what was not the most timely trade in Rangers history, Perry was dealt to the San Diego Padres for reliever Dave Tomlin and cash in early 1978. Perry proceeded to have the best season of his long career and with a 21-6 record and a 2.73 ERA he won his second Cy Young Award. In 1980, Perry was reacquired by the Rangers and won six games before being traded to the New York Yankees for reliever Ken Clay. He retired after the 1983 season with 314 career wins and was elected to the Hall of Fame in 1991.

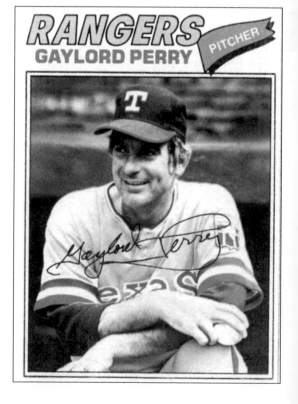

RANGERS PITCHER
GAYLORD PERRY

In the 1970s, when the Texas Rangers were mentioned, the player who most frequently came to mind was without a doubt Toby Harrah. An original Ranger, Harrah was drafted by the Senators in 1967 and made his Washington debut in 1969. The young shortstop reached his stride in the team's first season in Texas and he was the first Ranger named to the All-Star team. His clutch hitting and smooth fielding quickly made him a fan favorite in Arlington. Harrah went on to be named to two more All-Star teams and he had what was perhaps his best season in 1977 when he hit .263 with 27 home runs, 87 RBIs, and a league-leading 109 bases on balls. In December of 1978, Harrah was traded by the Rangers to the Cleveland Indians for another infielder who would have a great career in Texas, Buddy Bell. He eventually played for the Yankees before being traded back to the Rangers in 1985. Harrah fittingly wrapped up his career wearing a Texas uniform at the end of the 1986 season. Harrah remained with the organization for several years as a minor league manager and hitting instructor and in 1992 he managed the Rangers themselves for part of the season. Remaining active in area baseball, Harrah joined the coaching staffs of Texas Wesleyan University and the minor league Fort Worth Cats in 2003. (Photo by Tim Phillips.)

A versatile player who was gifted with the glove and solid with the bat, Lenny Randle was an original Ranger in 1972. In five seasons with the club, the switch-hitting Randle played seven different positions though he most frequently occupied second or third base. At the end of spring training in 1977, manager Frank Lucchesi informed Randle that he had lost his starting job. Words were exchanged that resulted in the usually good-natured Randle punching Lucchesi. He was promptly suspended, fined, and traded to the New York Mets—where he had the best season of his career. After his major league career ended in 1982, Randle moved to Italy, and was reportedly the biggest star in that country's professional baseball league.

Elliott "Bump" Wills was drafted by the Rangers in 1975 and two years later he won a job as the team's starting second baseman. The son of former Dodgers star Maury Wills, Wills showed that he had inherited some of his father's speed when he stole 52 bases in his second season as a Ranger. Though never developing into a true star, Wills was a solid player during his five seasons in Texas, batting .265 with 161 stolen bases. After the 1981 season he was traded to the Chicago Cubs for pitcher Paul Mirabella, a minor league player, and cash.

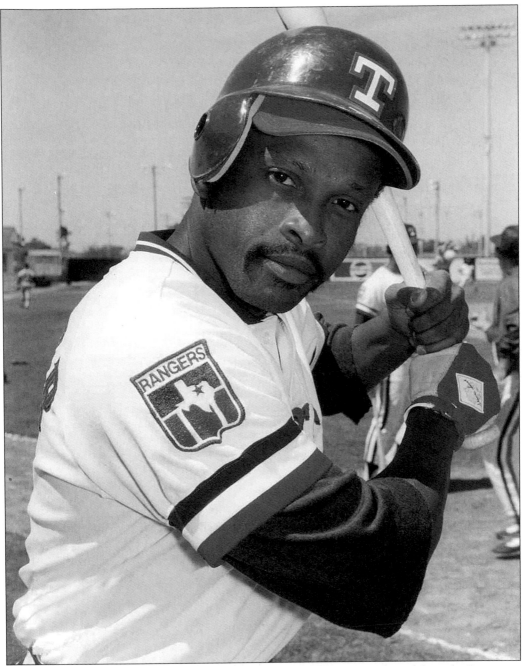

A former National League All-Star with Pittsburgh, Al Oliver was acquired from the Pirates in December of 1977 as part of a four-team trade. For four seasons he patrolled the Rangers' outfield and during that time he amassed 668 hits, hit for a .319 average and was twice named to the All-Star team. At the end of Spring Training in 1982 the Rangers traded Oliver to the Montreal Expos for third baseman Larry Parrish and first baseman Dave Hostetler. Though the Rangers missed out on what would be the best season of Oliver's career (he won the National League batting title in 1982 with a .331 average and led the league in hits, doubles, and RBIs), the deal was a sound one since Parrish would put in six and a half standout seasons with the team.

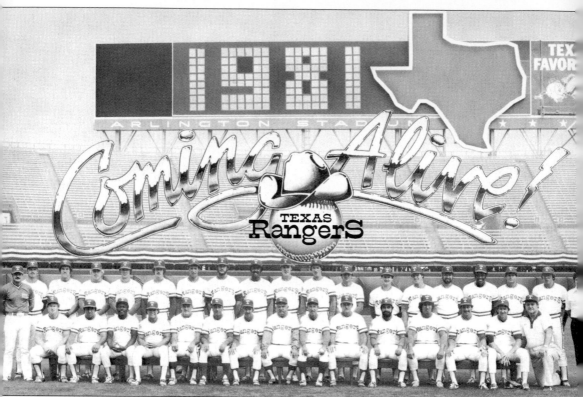

The 1981 Rangers, managed by Don Zimmer, just missed out on postseason play. On June 11, the day before a players' strike interrupted the season, the team blew a 3-1 sixth-inning lead against Milwaukee and lost, 6-3. Had they won that game, the Rangers would have been in first place. Teams in first when the strike commenced were deemed as winners of the first half of the season and they faced the winners of the post-strike second half in the play-offs. As it was, Oakland met Kansas City to determine the AL West champions. Despite missing the playoffs, the Rangers (57-48) still finished with the second best record in the division. The leaders of the offense that season were third baseman Buddy Bell (.294), outfielder Mickey Rivers (.286), and designated hitter Al Oliver (.309). The pitching staff featured starters Doc Medich (10-6, 3.08 ERA), Rick Honeycutt (11-6), and Danny Darwin (9-9) and closer Steve Comer (8-2, six saves).

The best third baseman to ever wear a Rangers uniform, Buddy Bell was a good hitter and a gifted fielder. Arriving in a 1978 deal that sent popular shortstop Toby Harrah to Cleveland, Bell got off to a great start in Texas and played every game in his first season, batting .299 with 18 homeruns, 101 RBIs and 200 hits. During the six and a half seasons he spent with the team, Bell won six Gold Glove awards and was named to three AL All-Star teams. In a trade that brought ace reliever Jeff Russell to Texas, Bell was sent to the Cincinnati Reds in mid-1985. As a free agent in 1989, however, he returned to the Rangers and played 37 games before announcing his retirement.

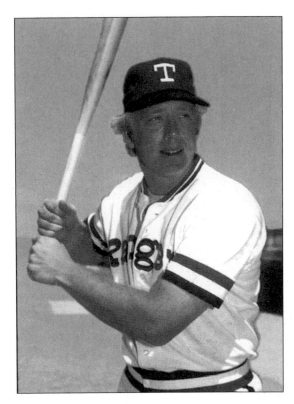

As famous for his strikeouts (185 in his rookie season) as his monster home runs, outfielder Pete Incaviglia, seen here on his 1989 baseball card, provided the slugging power for the Rangers of the late 1980s. In 1985, Incaviglia was named *Baseball America's* NCAA Player of the Year after his junior season at Oklahoma State. He was drafted in the first round that summer by the Montreal Expos but refused to sign until a deal was worked out in which he would be traded to the Rangers. He made the big league team the following spring without ever having played in the minor leagues and hit 30 homeruns as a rookie. "Inky" eventually spent five seasons in the Rangers' lineup before being given his release at the end of spring training in 1991. During that time he average 25 home runs and 78 RBIs per season. He went on to play for the Astros, Orioles, Phillies, Tigers, and Yankees, as well as in Japan, before retiring in 1999.

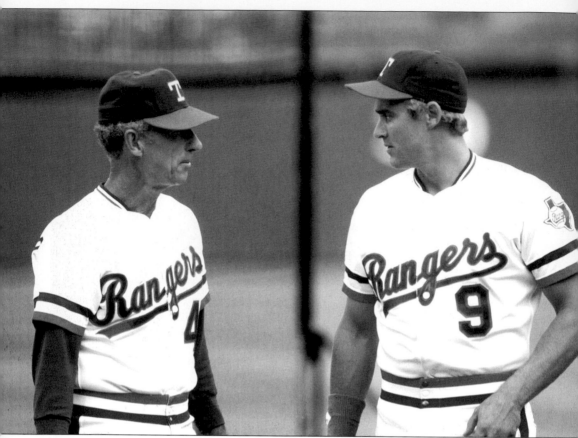

Wayne Terwilliger (left) and Pete O'Brien have both had a long relationship with baseball in the Dallas-Fort Worth area. Terwilliger played in the major leagues off and on from 1949 to 1960, primarily as a second baseman, with several teams. He was hired as a coach with the Senators and he moved with the franchise to Texas in 1972. Terwilliger left after that first season in Arlington but returned in 1981 and spent five more years with the Rangers. In 2003, he was hired to manage the minor league Fort Worth Cats. During the season he became the oldest person to manage a professional team at the young age of 78. O'Brien was the Rangers' slugging first baseman for much of seven seasons. Always a consistent performer, he rarely missed a game. His best season at the plate was 1986, when he batted .290 and hit 23 runs with 90 RBIs. In 1988, O'Brien was trade with Oddibe McDowell to the Cleveland Indians for Julio Franco. He retired in 1993 after spending four seasons with the Seattle Mariners. O'Brien returned to the game when he helped organize the group that revived minor league baseball in Fort Worth. He served as Director of Player Personnel for the Fort Worth Cats in 2001 and 2002. (Photo by Tim Phillips.)

Selected by the Rangers in the fifth round of the 1982 draft, Steve Buechele, seen here tipping his cap to fans after an ovation for a homerun, would go on to hold down the hot corner with the team for much of seven seasons. Though never a true star, he was a consistent performer in the field and at the plate after making his big league debut in July of 1985. Traded to Pittsburgh late in the 1991 season for Hector Fajardo and Kurt Miller, Buechele eventually went on to play for the Chicago Cubs. Released by the Cubs in July of 1995, he re-signed with the Rangers. Buechele's return to Texas was short-lived, however, and he played only a handful of games before retiring. (Photo by Tim Phillips.)

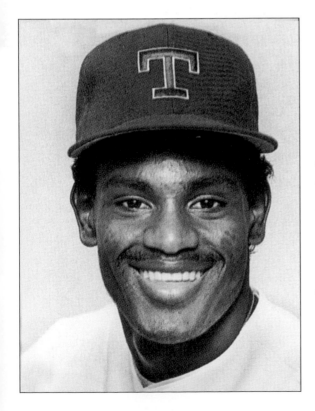

Though he has long been associated with the city of Chicago, superstar outfielder Sammy Sosa actually began his career with the Rangers. Signed as a teenager in the Dominican Republic in the summer of 1985, Sosa worked his way up through the Rangers' farm system and made his big league debut on June 16, 1989. On July 29th of that season, however, the Rangers traded him to the White Sox along with infielder Scott Fletcher and pitcher Wilson Alvarez for outfielder Harold Baines and infielder Fred Manrique. In a total of 25 games with the Rangers, Sosa batted only .238 with one home run.

83

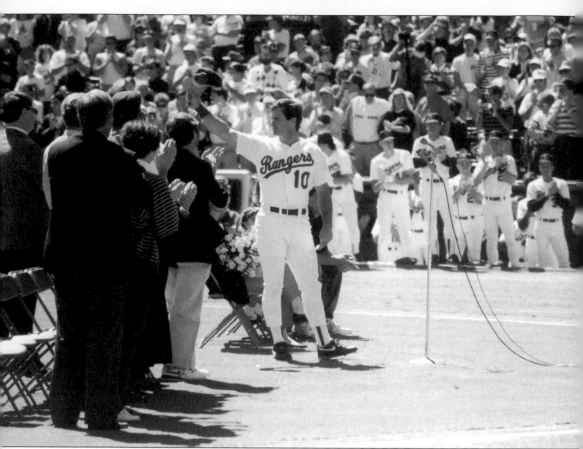

One of the best defensive catchers in the history of the game, Jim Sundberg was drafted by the Rangers in 1973 and made his big league debut on Opening Day 1974. For a decade he was the team's backstop, in the process winning six consecutive Gold Glove awards and a place on two American League All-Star teams. In 1984 Sundberg was traded to Milwaukee and then with the Royals in 1985 he won a World Series. In 1988 he returned to the Rangers as a free agent and closed out his playing career with the team in 1989. Though not a powerful slugger at the plate, Sundberg was a solid hitter and he retired with a .248 career average and nearly 1,500 hits. Sundberg, seen here being honored by the team and fans during his final season, maintained a relationship with the Rangers. For six years he was color analyst for Texas Rangers Television and in 2003 he served as Rangers roving minor league catching instructor, working with players in Frisco and other Rangers' farm clubs. (Photo by Tim Phillips.)

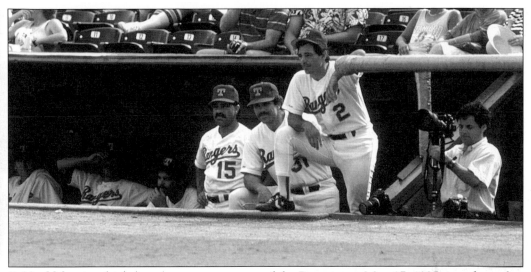

Bobby Valentine (right) took over as manager of the Rangers on May 17, 1985, just days after his 35th birthday. The fifth player chosen in the 1968 draft, Valentine had a ten-year career as a versatile utility player with five different teams before becoming a coach with the New York Mets. In nearly eight seasons at the helm of the Rangers, he compiled a 581-605 record before being replaced by Toby Harrah on July 9, 1992. Seen here with Valentine are coaches Davey Lopes (left) and Tom Robson. Lopes, a former All-Star infielder with the Dodgers, served as the Rangers' first base coach from 1988 to 1991. He went on to manage the Milwaukee Brewers. Robson, who played for the Rangers briefly in the mid-1970s, later served as hitting coach with the Mets and the Reds. (Photo by Tim Phillips.)

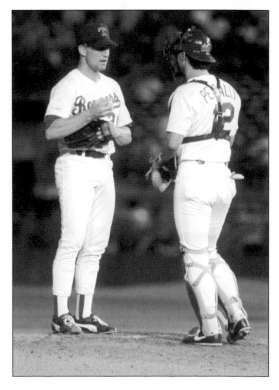

Pitcher Bobby Witt and catcher Geno Petralli have a discussion on the mound in this late 1980s photo. Witt was the Rangers first round pick (third overall) in the 1985 draft and he won a spot in the starting rotation in 1986. Though wild early in his career (he led the league in both walks and wild pitches) the hard-throwing Witt became a solid started for the Rangers. He had a career-best year in 1990, when he went 17-10 with a 3.36 ERA and 221 strikeouts. Traded to Oakland as part of the Jose Canseco deal, Witt returned to Texas in 1995 for three seasons. He retired after winning a World Series ring with the Arizona Diamondbacks in 2001. Geno Petralli joined the Rangers in 1985 and spent nine seasons as a backstop with the team. For several years he was the starting catcher before becoming a mentor to young Ivan Rodriguez. Though he didn't have much power at the plate, Petralli was good with the glove and his versatility allowed him to fill in at other positions, particularly third base. (Photo by Tim Phillips.)

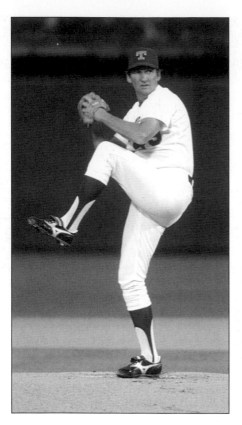

After a decade in a Dodgers' uniform, knuckleball pitcher Charlie Hough joined the Rangers in mid-1980. Primarily a middle-reliever with the Dodgers, Hough was given a chance to start by the Rangers in 1982 and he responded with 16 wins. He went on to lead the league with 17 complete games in 1984 and 285 innings pitched in 1987. In 1986, a season in which he finished 17-10, Hough was named to the AL All-Star team. When he left the Rangers in 1990, he was the team's all-time leader in wins (139), innings pitched, strikeouts, games pitched, losses and walks. Hough finished his career with the Florida Marlins and in 1993 he won the first game in the history of that franchise. (Photo by Tim Phillips.)

In March of 1989, a group of investors headed by George W. Bush and Rusty Rose purchased the Rangers from Eddie Chiles. Here, in an early 1990s photo, future Texas governor and U.S. President Bush enjoys a game with his father, former president George Bush, daughters Jenna and Barbara, and wife Laura. (Photo by Tim Phillips.)

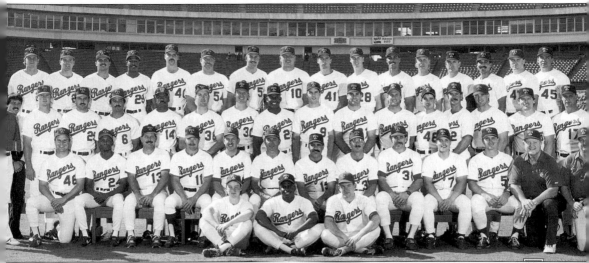

The 1991 Rangers took third in the AL West with an 85-77 record, finishing ten games behind eventual World Series champs Minnesota. That season saw Rangers' second baseman Julio Franco (.341) win the AL batting title, three players top the 200 hit mark (Franco, Rafael Palmiero and Ruben Sierra—the team's three All-Stars) and pitcher Nolan Ryan toss his record seventh no-hitter. Season attendance for the Rangers was 2,297,720, a total that ranked the Rangers seventh in the American League.

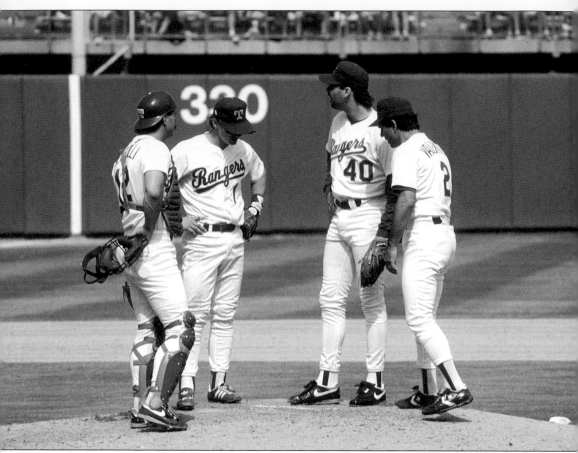

Catcher Geno Petralli, second baseman Scott Fletcher, closer Jeff Russell and manager Bobby Valentine have a conference at the mound in this 1989 photo. Russell was part of the 1985 trade that sent Buddy Bell to Cincinnati. A former starter who had led the National League with 18 losses in 1984, Russell developed into one of the game's top closers with the Rangers. He was a two-time All-Star and led the American League with 38 saves in 1989. Traded to Oakland in 1992 as part of the deal for Jose Canseco, he returned to the Rangers as a free agent in 1995. Russell saved 20 games that season and again pitched well in 1996 as a middle reliever before retiring from the game. (Photo by Tim Phillips.)

Pitcher Jamie Moyer came to the Rangers in late 1988 as part of a nine-player deal that also brought Rafael Palmeiro to Texas. His two seasons with the team were unmemorable and he failed to find success as a starter or reliever. In December of 1990, Moyer was released by the Rangers, a move the organization probably regrets in hindsight. He went on to have stints with the Cardinals, Orioles and Red Sox. In 1996, he joined the Seattle Mariners and at age 33, when many players are thinking of retirement, his career took off. Moyer posted a 17-5 record in 1996, was 20-5 in 2001, and in 2003, at age 40, he made his first All-Star team and won 21 games for the Mariners. (Photo by Tim Phillips.)

Jose Guzman signed with the Rangers organization as an 18 year old out of Puerto Rico in 1981 and proceeded to work his way up through the farm system. In 1985, he made his debut with the big league club and over the next six seasons Guzman won 66 games as one of the Rangers' most reliable starters. He signed with the Chicago Cubs as a free agent in 1993 but the following season his big league career came to an end due to injury. Guzman renewed his ties with the area in 2001 when he joined the minor league Fort Worth Cats for two seasons. (Photo by Tim Phillips.)

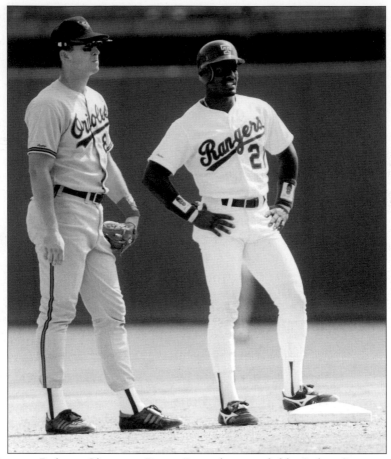

Hailed as the next Roberto Clemente, Puerto Rican-born outfielder Ruben Sierra was one of the most highly regarded young talents in baseball when he signed with the Rangers as a teenager in the fall of 1982. In June of 1986 he made his debut with the big league club at age 20 and soon appeared to be living up to the hype. The next season he hit 30 home runs and drove in 109 runs. Sierra had a tremendous year in 1989 (.306, 29 HR, 119 RBIs, 194 hits, 14 triples) and just missed being named the American League MVP. In a reported search for more power, Sierra began a serious weightlifting program after the 1989 season. He bulked up, but he also lost some of the speed and flexibility that had made him such a special talent. Late in the 1992 season, Sierra was traded by the Rangers, along with pitchers Jeff Russell and Bobby Witt, to Oakland for star outfielder Jose Canseco. He had a couple of decent seasons with the Athletics, but his career appeared to on the downslide. Sierra proceeded to drift around the major leagues, playing for six teams in four years before being released early in the 1998 season by the White Sox. He then spent time in Mexico and playing independent ball before the Rangers gave him another chance with a minor league contract in 2000. He played well at Oklahoma City and that September he earned a call-up to rejoin the team he started his career with. In 2001 Sierra returned to the Rangers, hit .291 with 23 home runs and was named AL Comeback Player of the Year. The following season he signed with Seattle but it was back to the Rangers in 2003 on a minor league contract. He made the big league club out of Spring Training and played well enough to draw the attention of the New York Yankees, who were looking for a powerful left-handed bat. He was traded to the Yankees that June and went on to play in the World Series. Though his career was not what it might have been, Sierra still has to be considered one of the most talented players to ever wear a Rangers jersey. (Photo by Tim Phillips.)

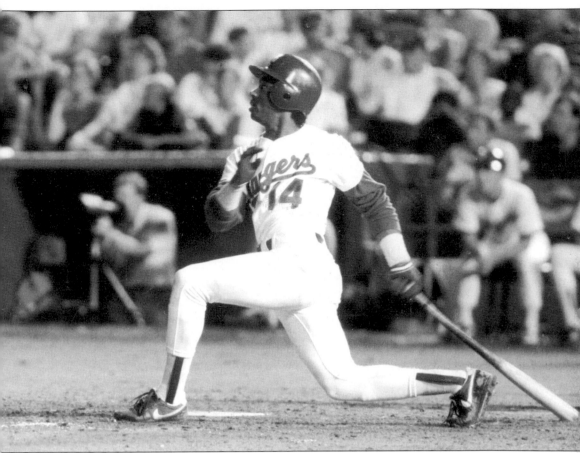

Julio Franco began his career with Philadelphia in 1982 and established himself as a potential star with several standout seasons for Cleveland. In need of a middle infielder who could hit, the Rangers traded first baseman Pete O'Brien, outfielder Oddibe McDowell and second baseman Jerry Browne to the Indians for Franco in December of 1988. It proved to be a good trade for the Rangers as Franco went on to win the American League batting title in 1991 with a .341 average and was named to three consecutive All-Star teams. In all, Franco played five seasons for the Rangers before joining the White Sox as a free agent in 1994. (Photo by Tim Phillips.)

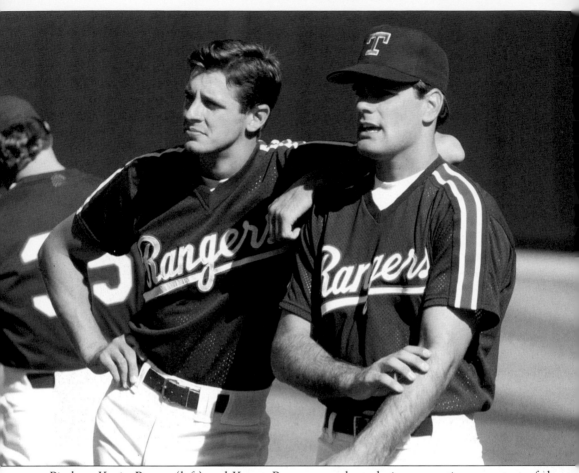

Pitchers Kevin Brown (left) and Kenny Rogers, seen here during a practice, were two of the Rangers top pitchers of the 1990s. Brown was selected by the Rangers in the first round (fourth overall) of the 1986 draft. He made his debut and won his first big league game that September. In 1989, he became a member of the starting rotation and won 12 games. Brown quickly developed into an ace starter and his best season with the Rangers was in 1992, when he led American League with 21 wins and was named to the All-Star team. Before becoming a free agent and signing with Baltimore after the 1994 season he won a total of 78 games in a Texas uniform. Brown went on to be an All-Star five more times and he helped the Florida Marlins win the World Series in 1997. He signed a free agent deal with the Dodgers in 1999 that made him the highest paid player in the National League. The left-handed Rogers was not a highly regard prospect when drafted by the Rangers in the 39th round in 1982. He persevered, however, and in 1989 he made the big league team as a reliever. In 1992 he appeared in half of all Rangers' games. The following season Rogers was converted to a starter and he did well, finishing with a 16-10 record. In 1994 he was perfect; on July 28, facing the California Angels, Rogers pitched only the 11th regular season perfect game in major league history. Named to the American League All-Star team in 1995, Rogers turned in a 17-7 record. A free agent after the 1995 season, he signed with the Yankees and won a World Series ring with that team. Rogers also played for Oakland and the New York Mets before returning to the Rangers in 2000. He spent three more seasons in Texas, twice winning 13 games, before signing a one-year deal with Minnesota. In 2004, Rogers returned to the Rangers for a third time. (Photo by Tim Phillips.)

Jose Canseco, the 1988 American League MVP while with Oakland, joined the Rangers late in the 1992 season when acquired from the Athletics in exchange for Ruben Sierra, Jeff Russell and Bobby Witt. Though he appeared to be a superstar in his prime, the slugging outfielder never quite lived up to expectations with the Rangers. In 1993 he batted only .255 with 10 home runs in 60 games before his season was cut short by an ill-fated attempt at pitching in which he hurt his arm. Canseco returned in 1994 and played well, hitting .282 with 31 home runs and 90 RBIs, but he left to sign with the Boston Red Sox after the season via free agency. (Photo by Tim Phillips.)

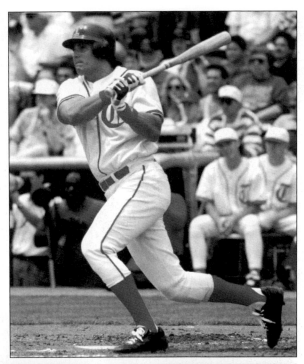

The Rangers selected high school player Dean Palmer in the third round of the 1986 draft. The young third baseman quickly rose through the minor league ranks and in September of 1989 he made his debut in Arlington. Palmer showed promise of becoming a great power hitter but unfortunately had a tendency to strikeout with alarming frequency (he led the American League with 154 strikeouts in 1992). He did have some good seasons with the Rangers, his best coming in 1996, when he batted .280 with 38 home runs and 107 RBIs. In the middle of the 1997 season, the Rangers, in need of a center fielder and believing they had a promising third base prospect, traded Palmer to the Kansas City Royals for Tom Goodwin. Palmer was an All-Star for the Royals in 1998 and he went on to have a couple of standout seasons with Detroit before announcing his retirement due to injuries in early 2004. (Photo by Tim Phillips,)

Outfielder Juan Gonzalez made his Texas debut at age 19 in 1989 and was soon on his way to becoming one of the greatest players in the history of the franchise. At age 21 he drove in over 100 runs and in 1993, a season in which he hit batted .310, hit 46 home runs and drove in 118, Gonzalez was named to his first All-Star team. In 1996, Gonzalez won the American League's Most Valuable Player award as he led the Rangers to their first-ever playoff appearance. Two seasons later he surpassed his own team RBI record with 157 and hit .318 with 45 home runs and 110 runs scored as he took his second AL MVP award. After the 1999 season Gonzalez was traded to the Detroit Tigers in exchange for Frank Catalanotto, Gabe Kapler, Franciso Cordero, Bill Haselman and Justin Thompson. As a free agent in 2002, the future Hall of Famer re-signed with the Rangers for two seasons. Gonzalez played well when healthy but injuries unfortunately limited him to roughly half a season in both 2002 and 2003. He joined the Kansas City Royals in 2004. (Photo by Tim Phillips.)

With an MVP award, a string of ten-straight Gold Glove awards and ten-straight All-Star Game appearances, Ivan Rodriguez (*above and below*) is one of the game's greatest catchers.

Signed by the Rangers as a 16-year-old, the native of Puerto Rico made his big league debut in 1991 at age 19. It wasn't long before his defensive skills had made him a star and his cannon-like arm had put fear into many would-be base stealers. At the plate Rodriguez also excelled, hitting for both average and power. In his MVP season of 1999, he batted .332 with 35 home runs, 113 RBIs, 25 stolen bases, 119 hits and 116 runs scored. A free agent after the 2002 season, Rodriguez signed with the Florida Marlins. He proceeded to lead that team to a World Series title in 2003. (Photo by Tim Phillips.)

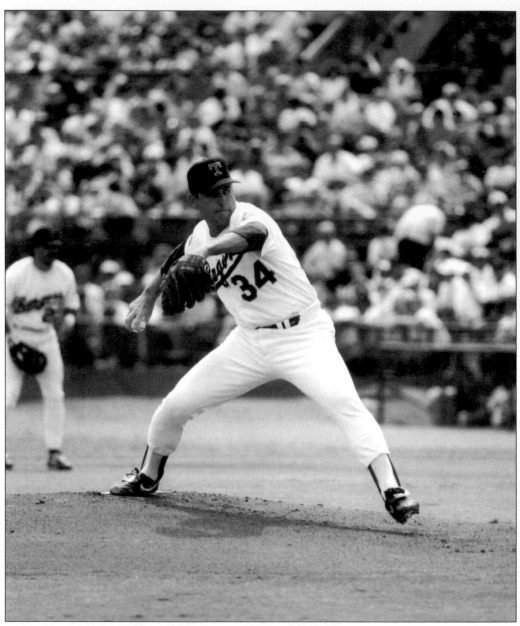

Nolan Ryan (*above and opposite top*) was already well on his way to Cooperstown after an outstanding career with the California Angels and the Houston Astros before joined the Rangers in 1989 at age 42. With Texas, however, he firmly established himself as one of the game's all-time legendary pitchers. As a Ranger, Ryan recorded his 5,000th strikeout, won his 300th game, pitched his sixth and record seventh no-hitters, twice led the American League in strikeouts and was named to the 1989 All-Star team. He pitched his final game for the Rangers on September 12, 1993, a date designated as Nolan Ryan Appreciation Day. The Rangers lost 4-2 but Ryan was honored in an on-field ceremony after the game. In 1996, Ryan's number 34 was retired by the Rangers. The Astros and the Angels did the same, making Ryan the only player to have his number retired by three teams. He was inducted into the Hall of Fame in 1999 and became the first to have a Rangers cap on his plaque in Cooperstown. (Photo by Tim Phillips.)

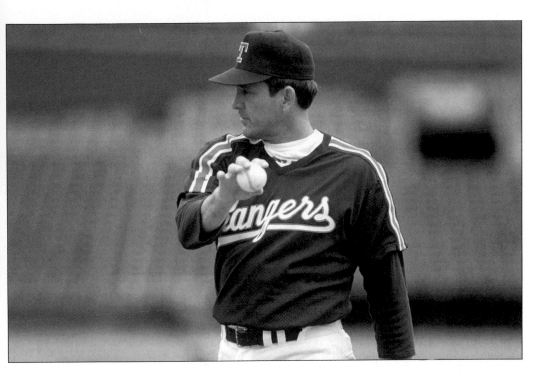

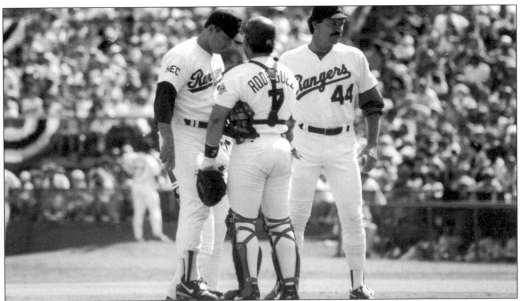

In a 1993 photo, manager Kevin Kennedy summons a relief pitcher to take over for Nolan Ryan. Kennedy, a former coach with the Montreal Expos, was hired as Rangers manager in October of 1992. In his first season with the team, the Rangers finished second with an 86-76 record. The following season, his last in Texas, Kennedy had the Rangers in first place before the players' strike prematurely ended the season. (Photo by Tim Phillips.)

On August 12, 1994, professional baseball players went on strike for the eighth time in the game's history, ending the season and denying the first-place Rangers a chance to make their first playoff appearance. The following spring, team owners announced they would carry on with out their regular players and hired replacement teams for Spring Training. The Rangers replacement team, seen here, was made up primarily of upper level minor league players who were not considered top prospects. The strike eventually lasted 234 days before a resolution was reached and play got underway on April 25, 1995. Though baseball eventually recovered, the effects of the strike were felt for several seasons as teams experienced large attendance drops. For the Rangers, 1994 attendance was 2,503,180 while it was only 1,985,910 the following season.

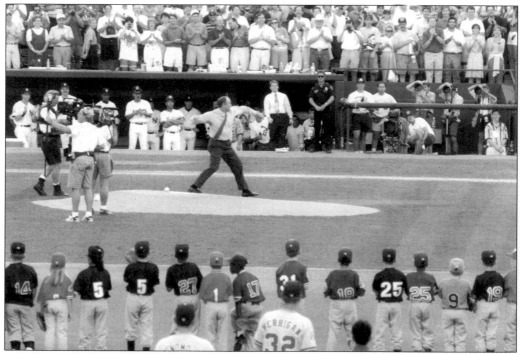

In 1995, the Rangers hosted the 66th All-Star Game at the Ballpark in Arlington. Above, Nolan Ryan throws out the first pitch. The National League won the game, 3-2. Catcher Ivan Rodriguez and pitcher Kenny Rogers represented the Rangers in the game. (Photo by Tim Phillips.)

First baseman Will Clark is seen here waiting in deck during a 1995 game. After eight standout seasons with the San Francisco Giants, Clark became a free agent and was signed to a five-year contract by the Rangers after the 1993 season. He replaced Rafael Palmeiro, his college teammate, in the lineup and played well, winning a spot on the 1994 All-Star team. Clark's best season in Texas was his last as he hit .305 with 102 RBIs, 23 home runs, and 98 runs scored in 1998. After that season he signed with Baltimore, where he again replaced Rafael Palmeiro as Palmeiro returned to the Rangers. Clark retired after the 2000 season with 2,176 hits and a career .303 batting average.

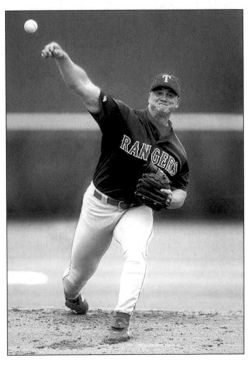

The Rangers selected pitcher Rick Helling in the first round of the 1992 draft. He made it to the big leagues in 1994 and had several trials with the team before being traded to the Florida Marlins for veteran hurler John Burkett in mid-1996. Late in the following season, however, Helling was traded back to the Rangers for reliever Ed Vosberg. Made into a fulltime starter in 1998, Helling with responded with a 20-7 record and led the American League in wins. He posted winning records in each of the following three seasons (13, 16, and 12 wins, respectively) before leaving to join the Arizona Diamondback as a free agent. Late in the 2003 season, Helling was traded back to the Marlins and he contributed to that team's surprising World Series success.

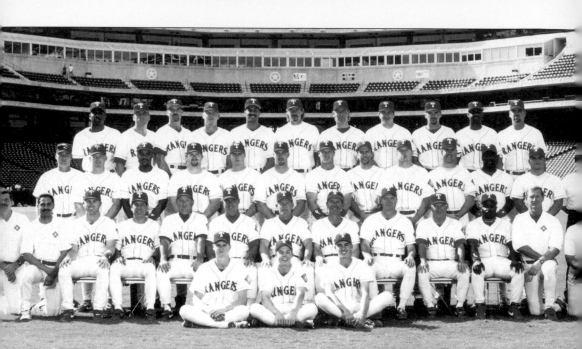

1996 TEXAS RANGERS
American League
Western Division Champions

After winning the AL West by four-and-a-half games over of the Seattle Mariners, the Rangers (92-70) finally made the playoffs in 1996. With a.284 team batting average and 221 combined home runs, the Rangers had a powerful offense that included Juan Gonzalez (.314, 47 HR, 144 RBIs), shortstop Kevin Elster (.252, 24 HR, 99 RBIs) and first baseman Will Clark (.284, 72 RBIs). The pitching staff was led by Ken Hill (16-10, 3.63 ERA), Darren Oliver (14-7), and All-Star Roger Pavlik (15-8). The Rangers won the first post-season game in franchise history that season as they defeated the Yankees, 6-2, in New York in Game One of the American League Divisional Series. They would lose the series, however, to the eventual World Champs.

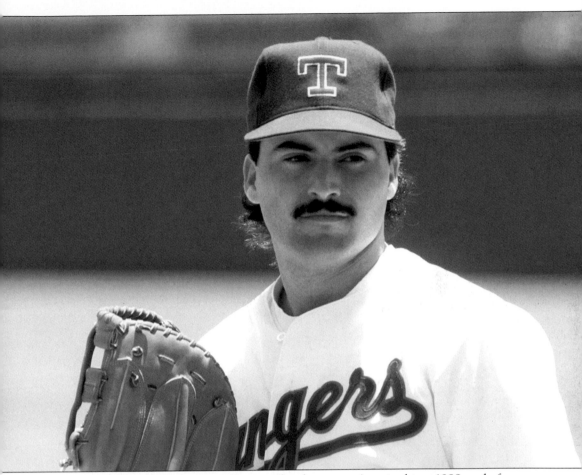

Rafael Palmeiro was the all-time greatest Rangers first baseman. Acquired in a 1988 trade from the Chicago Cubs after only one full season in the major leagues, Palmiero showed skill with the glove but displayed little power. He hit only eight home runs in his first season in Texas but soon developed into one of the game's premier sluggers. In his first five-season stint as a Ranger, he averaged 93 runs scored, 86 RBIs and 21 homeruns per season. After the 1993 season Palmeiro left as a free agent to spend five seasons with the Baltimore Orioles but returned to the Rangers for five more seasons beginning in 1999. During his second stay in Texas, the future Hall of Famer won a pair of Gold Glove awards and averaged nearly 43 home runs, 122 RBIs, 97 runs scored and 98 walks per season. In 2003, he joined an elite club when he hit his 500th career home run and finished the season with 528, a total that put him 13th on the all-time list. To the disappointment of many fans, Palmeiro was not retained after the 2003 season and he returned to the Orioles. (Photo by Tim Phillips.)

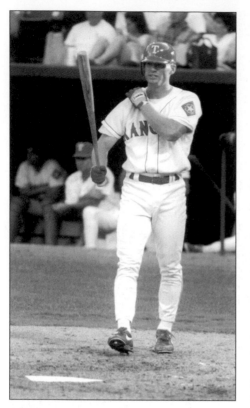

Probably one of the most popular Rangers ever, Rusty Greer (*above and below*) epitomized the word hustle. Drafted in the 10th round in 1990, Greer debuted in the Texas outfield in 1994 and soon won over fans with his bat and his spectacular fielding. He owned left field in Arlington and at the plate he consistently hit over .300 and drove in 100 or more runs three times. Greer's all-out style of play finally began to take its toll in 2000 and he faced the first in a string of injuries. He played only 62 games in 2001 and 51 more the following season before undergoing several operations that sidelined him for the entire 2003 season. As of this writing in 2004, Greer was still on the Rangers' roster but not expected to return to active duty any time soon if ever. (Photo by Tim Phillips.)

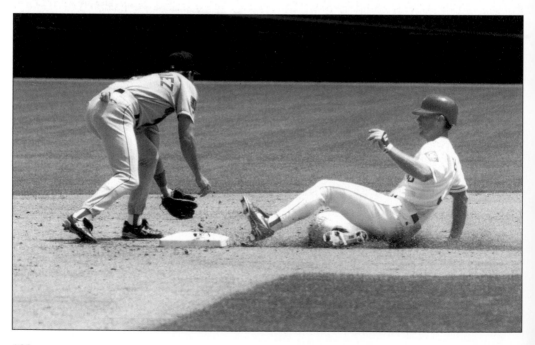

Drafted in the first round by the Dodgers but eventually traded to the Kansas City Royals, Tom Goodwin developed into one of the top centerfielders in the American League. Needing speed in the outfield and on the base paths more than they needed a power hitter, the Rangers traded third baseman Dean Palmer to the Royals for Goodwin in the middle of the 1997 season. Goodwin played two and a half seasons in a Rangers' uniform before signing with the Colorado Rockies as a free agent. His best season in Texas was 1998, when he batted .290 with 38 stolen bases and 102 runs scored.

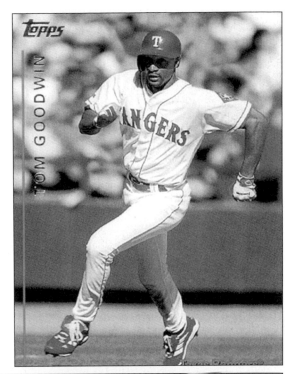

Free-agent pitcher John Thomson was signed by the Rangers before the 2003 season. A veteran of five big league seasons, four and a half of them with the Colorado Rockies, Thomson was put into the Rangers starting rotation. He got off to slow start but went on to win seven of his last nine starts and finish with a 13-14 record. With the Rangers opting to focus on developing younger pitchers in their system, Thomson was not retained for 2004 and he signed with the Atlanta Braves. (Photo by Andrew Woolley.)

Mark Teixeira was drafted by the Rangers in the first round (fifth overall) in 2001. An All-American and 2000 NCAA Player of the Year at Georgia Tech, he spent just one season in the minor leagues before making his debut in Arlington in 2003. Used primarily at first base in his rookie season, Teixeira showed great promise and hit .259 with 26 home runs and 84 RBIs. (Photo by Andrew Woolley.)

The Rangers had great hope for Hank Blalock after they drafted him in the third round in 1999. The young third baseman didn't disappoint as he worked his way up through the minor league system and made his big league debut at age 21 in 2002. In 2003, his first full season in the major leagues, Blalock batted .300 with 29 home runs and 90 RBIs and was named to the AL All-Star team. (Photo by Andrew Woolley.)

Drafted by the Rangers in the fourth round out of the University of Delaware in 1999, outfielder Kevin Mench has shown great promise. After winning an MVP award in the Florida State League in 2002 and having an outstanding 2001 season with Tulsa in the Texas League, Mench earned a promotion to the big league club in 2002. He quickly won praise as one of the top rookies in the American League and finished the season with a .260 batting average and 15 home runs in 110 games. He battled a series of injuries in 2003 and spent time rehabbing in the minor leagues but still managed to hit .320 with two home runs and 11 RBIs in 38 games with the Rangers. (Photo by Andrew Woolley.)

Originally a Toronto Blue Jays prospect, infielder Michael Young was sent to the Rangers in July of 2000 in exchange for pitcher Esteban Loaiza. By the following season the rookie had won the job as starting second baseman. Already a gifted fielder with a strong and accurate arm, Young also showed he could hit and consistently improved at the plate. In 2003, Young had an outstanding season as he batted .306 with 204 hits, 106 runs scored, and 72 RBIs. (Photo by Andrew Woolley.)

Shortstop Alex Rodriguez (*above and below*) was the talk of the sports world when he signed a record-shattering 10-year, $252 million deal with the Rangers on December 11, 2000. Regarded by many as the best all-around player in the game, Rodriguez had won a batting title in 1996 with Seattle at the age of just 20. Rodriguez got his Texas career off to a tremendous start in 2001 as he batted .318, hit 52 home runs, had 201 hits, scored 133 runs, drove in 135, and played all 162 games. He followed that performance with 57 home runs and 142 RBIs in 2002. In 2003, Rodriguez finally won the American League's Most Valuable Player award as he led the league with 124 runs scored and 47 home runs and won a second consecutive Gold Glove at shortstop. Though originally planned to last ten years, the Alex Rodriguez era in Texas came to an end after only three. With the organization essentially suffocating under his massive contract, Rodriguez became the first reigning MVP to be traded as he was sent to the New York Yankees in exchange for All-Star second baseman Alfonso Soriano in February of 2004. (Photo by Andrew Woolley.)

FIVE

Minor League
Baseball Returns

In a joint venture between Mandalay Sports Entertainment, owners of several minor league teams across the country, and Southwest Sports Group, the company headed by Rangers' owner Thomas Hicks, minor league baseball made a return to the Dallas area in 2003. The home chosen for the new team was the fast-growing Collin County suburb of Frisco, located north of Dallas.

It was a complicated move to bring a team to the area. First, Hicks had to buy the Shreveport Swamp Dragons franchise and receive approval from the Texas League for the move. Wanting to make the new team a part of the Rangers' organization, he then had to renegotiate his player development agreement with the Tulsa Oilers, the team that had been the Rangers' Texas League affiliate since 1977. All of this was accomplished (Tulsa became a Colorado Rockies affiliate) and plans were made for the new Frisco team, named the RoughRiders, to play their inaugural season in 2003.

On the surface it might seem that the RoughRiders would compete with their parent Rangers for the entertainment dollars of the area. Instead, placing a team in Frisco, nearly an hour drive from the Rangers' home in Arlington, has opened up a whole new market for baseball fans. Fans of the RoughRiders will most likely also become Rangers fans, since many of the top players who come through Frisco may end up playing in Arlington.

The RoughRiders new state-of-the-art playing facility, Dr. Pepper/Seven Up Ballpark, was ready for Opening Day in 2003. Over the course of the season, 706,543 fans passed through the turnstile, a total that ranked the team fourth in total attendance of the 117 minor league clubs in the country. By comparison, the Rangers themselves drew less that 700,00 in each of their first two seasons in Texas.

Texas Rangers owner Thomas Hicks, also part owner of the Frisco RoughRiders speak with members of the media during Opening Night festivities in Frisco. Hicks and his Southwest Sports Group company have played an important role in Dallas area sports. Frisco was also chosen as the new home for the training facility of Hicks' Dallas Stars hockey team, the 1999 Stanley Cup champions. (Courtesy of A. Kaye Photo/Frisco RoughRiders.)

Rafael Palmeiro, veteran star first baseman for the Texas Rangers, throws out the first pitch on April 3, 2003, Opening Night in Frisco. Palmeiro had also participated in the official groundbreaking at the stadium in February 2002. (Courtesy of A. Kaye Photo/Frisco RoughRiders)

The Opening Night crowd pours through the gates at Dr. Pepper/ Seven Up Ballpark to see the RoughRiders take on the Tulsa Drillers. Average attendance for Frisco in 2003 was 9,296 fans per game. (Courtesy of A. Kaye Photo/Frisco RoughRiders.)

Former Dallas Cowboys quarterback Troy Aikman throws out the ceremonial first pitch before a RoughRiders game. (Courtesy of A. Kaye Photo/Frisco RoughRiders.)

The RoughRiders' mascot, Deuce the groundhog, comically harasses a Texas League umpire. Like most minor league teams, the RoughRiders have gone to great lengths to turn an evening at the ballpark into family entertainment that is fun for fans of all ages. (Courtesy of A. Kaye Photo/Frisco RoughRiders.)

Edwin Moreno, a highly regarded pitching prospect in the Rangers organization, spent the 2003 season in Frisco. Used as both a starter and reliever, he compiled a 6-5 record with a 3.29 ERA. (Photo by Andrew Woolley.)

Versatile infielder Marshall McDougall gained fame in college when he hit six home runs in one game for Florida State and was MVP of the 1999 College World Series. Drafted in the ninth round by Oakland, he was traded to Cleveland and then to Texas before the 2003 season. In 2002, while part of the Athletics' organization, McDougall played in the Texas League for Midland and batted .303 in 84 games. With Frisco, he batted .258 with 13 home runs and 69 RBIs in 110 games before earning a promotion to AAA Oklahoma City. (Photo by Andrew Woolley.)

The Rangers selected Midland, Texas native Laynce Nix out of high school in the fourth round of the 2000 amateur draft. A highly regarded outfield prospect, he worked his way up through the Rangers farm system and arrived in Frisco in 2003. With the RoughRiders, Nix hit .284 with 15 home runs and 63 RBIs in 87 games. Bypassing the AAA level altogether, he was called up to the Rangers in August. With the big league club he hit .255 in 53 games and was given a serious look as management planned for its outfield of the future. (Photo by Andrew Woolley.)

A unique feature of Frisco's Dr. Pepper/Seven Up Ballpark is the bullpen, which is surrounded by seats on all sides. Bullpen pitchers were one of the strengths of the 2003 RoughRiders. Closer Spike Lundberg (31 saves, 2.48 ERA) and middle relievers Erick Burke (64 appearances, 3 saves, 2.59 ERA) and Keith Stamler (44 appearances, 1 save) contributed greatly to the team's success. (Courtesy of A. Kaye Photo/Frisco RoughRiders.)

Outfielder Ramon Nivar, who also played second base and shortstop, was on fire in the first half of the 2003 Texas League season as he hit .347 in 79 games with Frisco. Promoted to Oklahoma City, the 23-year-old native of the Dominican Republic proved he could hit AAA pitching just as well and batted .337 in 23 games. Promoted again to the big leagues, Nivar hit .211 in 28 games during August with the Rangers. Fortunately for the RoughRiders, he was returned to the team for the Texas League playoffs. In January of 2004, the Rangers announced that Nivar was the recipient of the organization's 2003 Tom Grieve Minor League Player of the Year Award. (Photo by Andrew Woolley.)

113

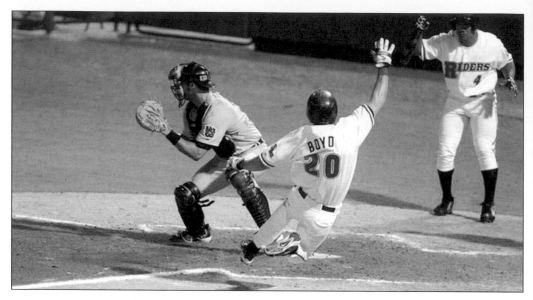

It did not take the RoughRiders long to impact the Texas League. After winning the first half championship of the Eastern Conference, the RoughRiders faced the Wichita Wranglers in the first round and swept them in three games at home. In the championship series against the San Antonio Missions the team was not so fortunate. After dropping the first game, 0-10, at San Antonio, the RoughRiders won a 5-3, 11-inning thriller. The next three games, however, ended in losses and the RoughRiders' inaugural season came to an end at home on September 13. The two photos on this page show RoughRiders playoff action. Above, outfielder Patrick Boyd, a former Clemson University star who was promoted to Frisco at mid-season, slides home safely to score. Below, infielder Jason Bourgeois, who was drafted by the Rangers out of Houston's Forest Brook High School, celebrates after scoring a game-winning run against Wichita. (Courtesy of A. Kaye Photo/Frisco RoughRiders.)

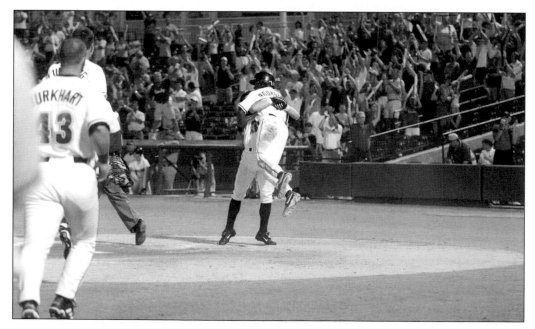

SIX

The Ballparks

The Dallas Hams, the city's first professional baseball team in 1888, played their home games at Oak Cliff Park in the Trinity River bottoms. The Houston Street viaduct currently runs over what was right field. Other early Dallas teams played at various sites around the city. In 1902 a field, named Gaston Park, was built at the State Fair grounds near the Texas and Pacific railroad tracks, near where the Music Hall is today.

In 1915, team owner Joe Gardner moved his ballclub from Gaston Park to a new facility on the west side of the Trinity River in Oak Cliff. Joe Gardner Park, as it was called, was located at the intersection of West Jefferson and Comal Streets. Next door was an ice-skating rink (reportedly the first in the South) which was also owned by Gardner.

In an accidental fire, Joe Gardner Park burned on July 19, 1924, immediately after a double-header with Wichita Falls. Nearby Riverside Park, home of black baseball in Dallas, was donated for the next day's game but Dallas Steers owner Ike Sablosky soon worked out a deal for the team to finish its schedule at the horseracing arena at the State Fairgrounds. In the first game played there, 16,484 fans turned out to see the Steers take on their arch-rival Fort Worth Panthers. The crowd set a Texas League attendance record that stood until 1950.

A new 8,000-seat ballpark, named Steer Stadium, was built in 1925 across the street from the site of Joe Gardner Park. Eventually renamed Rebel Stadium, the facility served the Dallas ballclub for 16 seasons until, like its predecessor, it was destroyed by fire in 1940. A new ballpark was soon constructed on the same site but it wasn't quite ready for Opening Day in 1941 and the Rebels had to play their first three "home" games at Katy Park in Waco. Rebel Stadium finally did open that April despite the fact that the bleachers were not complete. Due to a wartime shortage of materials, the ballpark remained without a roof until 1946. Official seating capacity for the ballpark as listed as 7,200 in 1946 and 9,000 in 1947 after expansion.

In 1948, Dick Burnett purchased the ballclub as well as the stadium. The following season he gave the facility his own name and christened it Burnett Field. Burnett turned his stadium into one of the nicest in minor league baseball as he added seats and raised the official seating capacity 10,324. Eventually, as a move was made to unite Dallas and Fort Worth baseball interests, it became apparent that a new stadium was needed. Burnett Field was eventually torn down in 1966, leaving the site at Colorado and Jefferson vacant.

In September of 1964, construction began on what would become known as Turnpike Stadium in the city of Arlington, mid-way between Dallas and Fort Worth. The ballpark, which cost $1.9 million and originally seated 10,000, became home to the Dallas-Fort Worth entry in the Texas League. Construction workers rushed to complete the park for the 1965 season, reportedly laying the last piece of sod just 36 hours before the first game and painting the foul lines during pre-game batting practice. In the end, however, the park was ready, and 7,231 fans turned out to watch the Dallas-Fort Worth Spurs beat Albuquerque on April 23.

As the area continued its push for a major league baseball franchise, Turnpike Stadium was enlarged to 20,000 seats after the 1970 season. Two years later, when it was announced that the Washington Senators were coming to town, the stadium was again enlarged to a seating capacity of 35,694 and its name was changed to Arlington Stadium. A scoreboard was added that featured a large outline of the State of Texas with stats listed inside.

Arlington Stadium served the Rangers well but as team attendance increased the Rangers and the City of Arlington agreed on a two-year program to renovate and enlarge it. For the 1978 season an upper deck was added and seating capacity was enlarged to over 41,000. Before that time, fans would enter at the top of the stadium and walk down to their seats, since the playing field was below the level of the surrounding parking lots. Later expansions raised capacity to its final level of 43,521.

In the late 1980s, with Arlington Stadium becoming outdated and the options to expand and renovate it limited, talk began about the possibility of constructing a new facility. The Rangers and the City of Arlington finally announced plans to build a new ballpark adjacent to the Arlington Stadium location in 1990. Arlington voters approve a one-half cent sales tax to finance up to $135 million of municipal bonds for construction and in April of 1992, construction began. Designed by David M. Schwarz and the architectural firm HKS, the new ballpark was designed to maintain an old-fashioned feel, yet have every possible modern amenity.

The Ballpark in Arlington, as the new facility was simply named, opened on April 1, 1994, when the Rangers hosted the New York Mets in an exhibition game. The first regular season game is played against the Milwaukee Brewers on April 11. The new ballpark was very well received by fans, bringing about a large boost in attendance with an average of 40,374 turning out for every home game in 1994.

In 1996, the Ballpark in Arlington saw playoff baseball finally come to the Dallas area as the Rangers took on the New York Yankees. The following season, on July 12, 1997, the ballpark was the site of the first regular season, inter-league game in major league history when the Rangers hosted the San Francisco Giants

The Dallas area is now the home to another state-of-the-art ballpark designed by the same architects who created the Ballpark in Arlington. In 2003 the new Dr. Pepper/Seven Up Ballpark, home to the Frisco RoughRiders of the Texas League, opened. Located in the northern suburb of Frisco at the corner of State Highway 121 and Dallas North Tollway, the ballpark gives the Dallas area two of the nicest baseball facilities in the country.

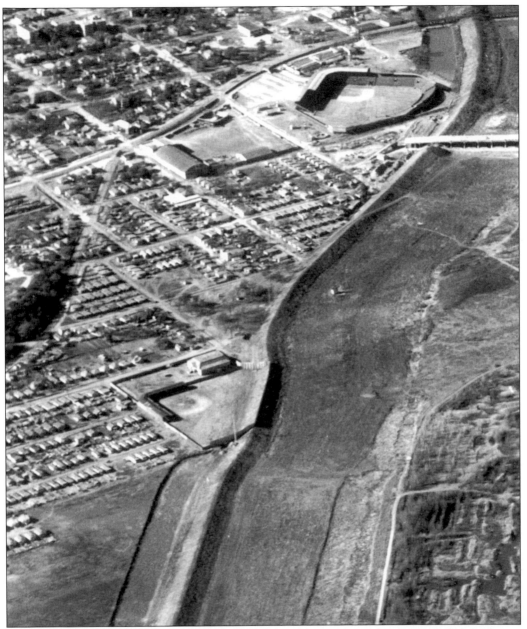

This 1930s aerial photo shows both Rebel/Steer Stadium (top) and Riverside Park, which was used by Dallas area Negro league teams for many years. Riverside Park, with the bank of the Trinity River levee apparently in play in left and center field, was home to teams including the black Dallas Giants of the Colored Texas League and later the Texas-Oklahoma-Louisiana League. Well-known players from those teams included outfielders Lee and Reuben Jones, who both went on to play for prominent Negro league teams in the North. (Courtesy of the Texas/Dallas History and Archives Division, Dallas Public Library.)

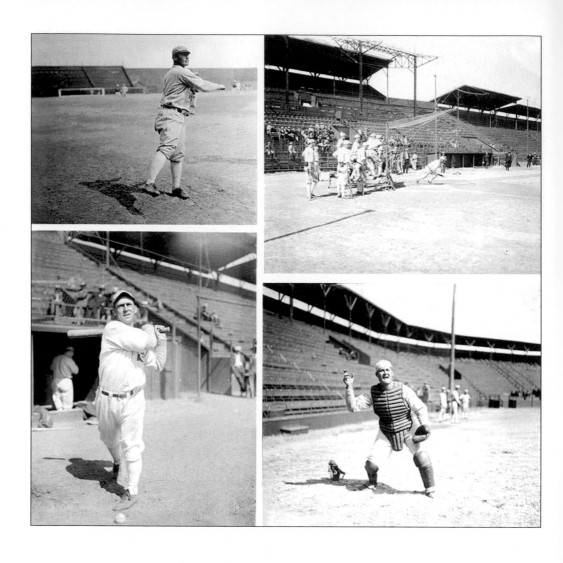

In 1929, the Chicago White Sox made a stop in Dallas during spring training. The images on these two pages of the White Sox holding practice show rare views of the interior of Steers Stadium. (Courtesy of the Library of Congress.)

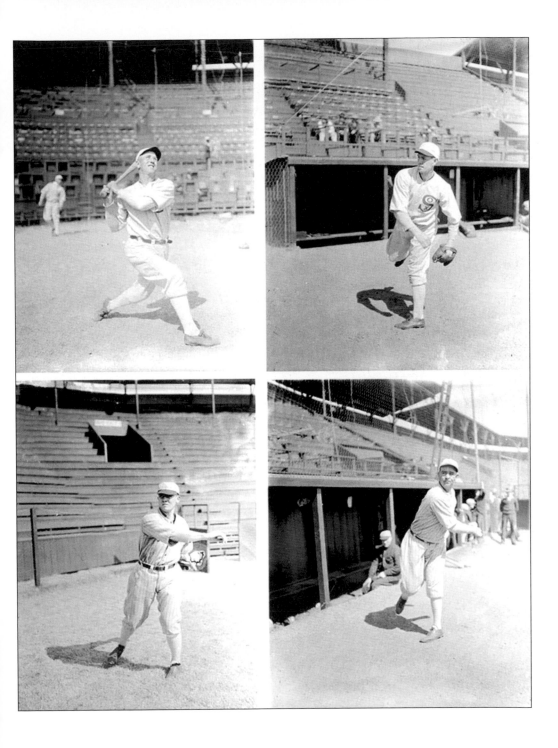

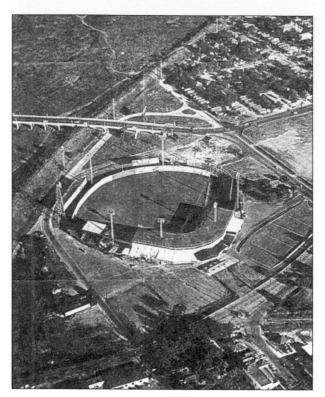

This 1930s aerial view shows Steer Field, which became known as Rebel Stadium when the team's name changed in 1939. When Dick Burnett bought the Dallas Rebels he also bought the stadium for an additional $265,000 and renamed it Burnett Field in 1949. In the early 1950s, the field measured 329 feet in right field, 361 feet in left center, 377 feet in center, 373 feet in right center, and 341 feet in right. There was a 20-foot fence with a second deck of 20-foot signs above and 40 feet behind the first fence. (Courtesy of the Texas/Dallas History and Archives Division, Dallas Public Library.)

The Dallas-Fort Worth Rangers are seen here taking batting practice at Burnett Field in 1961. From 1960 through 1963, the combined Dallas-Fort Worth team split its home schedule between Burnett Field and LaGrave Field in Fort Worth. By the late 1960s, both stadiums had been torn down.

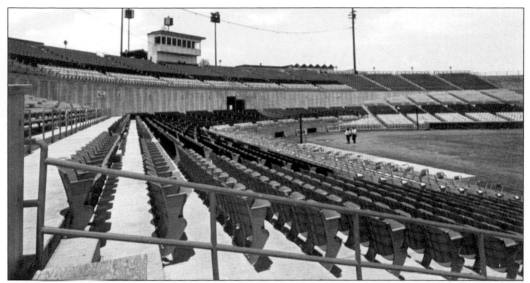

Turnpike Stadium, seen here in a late-1960s postcard, was home to a Dallas professional baseball from for nearly three decades. When Dallas and Fort Worth first began to field a combined team, home games were split between the two cities but as the area pushed for a major league franchise it was decided that a single home field was necessary. On a 137-acre site in the city of Arlington, mid-way between Dallas and Fort Worth and near the Six Flags theme park, construction got underway on a new ballpark. Named Turnpike Stadium, the 10,000-seat facility was completed for the 1965 season.

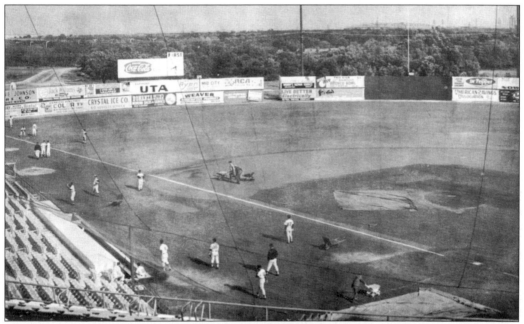

Since it was constructed in a natural bowl, the playing field at Turnpike Stadium was 40 feet below the surrounding land. The foul poles were 330 feet down either line and straightaway centerfield measured 400 feet. Expanded twice and renamed Arlington Stadium, the ballpark finally served its intended purpose when it became home to the major league Texas Rangers in 1972.

The bleacher section at Arlington Stadium, which ran from foul pole to foul pole, was the largest in the major leagues. Above it, the stadium featured the most advertising in the major leagues. (Photo by Tim Phillips.)

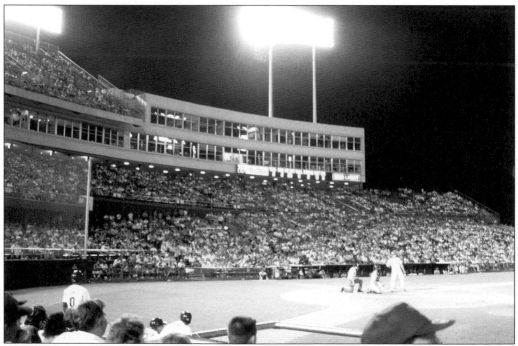

Due to the Texas heat, few day games were played at Arlington Stadium. Though not always the most pleasant to play in since it was considered the hottest park in the major leagues, Arlington Stadium was considered a hitters' park since the heat supposedly helped the ball carry farther.

Jim Anglea (left), seen here discussing field conditions with a member of his staff, served as the Rangers' head groundskeeper for several years. After leaving the Rangers, Anglea founded Anglea Turf Construction and Anglea Sod Farm in the town of Italy, Texas. The company, which specializes in athletic facility construction, is one of the most highly regarded in the industry. In addition to doing work at the Ballpark in Arlington, Anglea and his company have completed several other area projects in recent years. Among them are the San Angelo Colts stadium, LaGrave Field in Fort Worth, fields at the University of Dallas and numerous Texas high schools, as well as playing surfaces at the Florida Marlins' ProPlayer Stadium and Bricktown Ballpark in Oklahoma City. (Photo by Tim Phillips.)

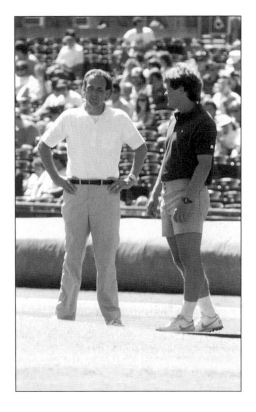

Though Arlington Stadium was only an average facility when compared to other major league ballparks, its playing surface was always considered one of the best. Here the ground crew is seen watering the infield in a late 1980s photo. (Photo by Tim Phillips.)

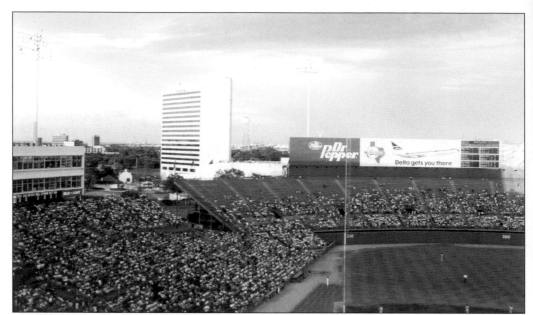

Arlington Stadium was located adjacent to the Six Flags Over Texas theme park. In the distance, to the right of the tall Marriott Hotel, rides at the park can be seen. The stadium was torn down in 1994 and the site is now a parking lot for The Ballpark in Arlington, the Rangers' current home. (Photo by Tim Phillips.)

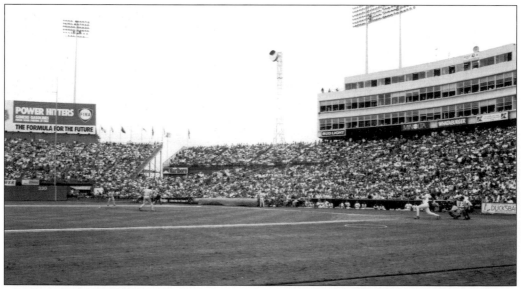

The last pitch at Arlington Stadium, seen here, took place on October 3, 1993, in a game between the Rangers and the Kansas City Royals. The game was also the last for George Brett, the Royals' future Hall of Fame third baseman. Overall, the Rangers played 1,689 games in the park and had an average attendance of 18,777. (Photo by Tim Phillips.)

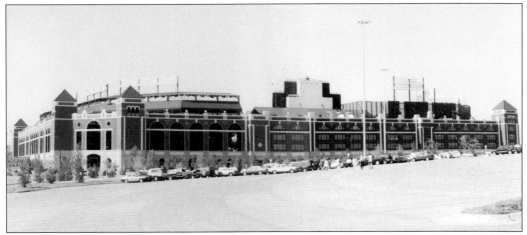

With a seating capacity of 49,178, The Ballpark in Arlington was constructed for a cost of $191 million. Designed to be extremely fan-friendly, it features a 17,000 square foot baseball museum (which is open year-round), a Rangers Walk of Fame where fans can read about Rangers teams of the past, numerous shop and restaurants, and 122 suites.

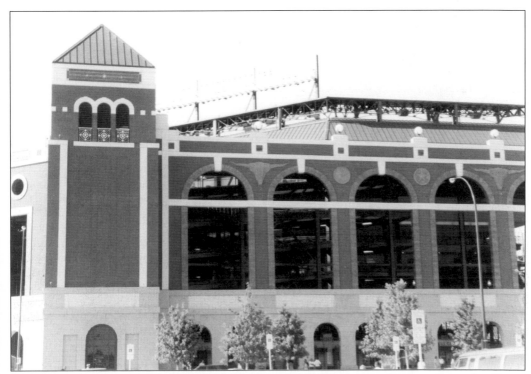

This view of some of the architectural details of the Ballpark in Arlington shows the Texas motifs, such as the 35 longhorn heads and 21 stars, which have been incorporated into the brick and granite facade of the stadium. Between the lower and upper arches on the outer façade are also a series of murals depicting Texas scenes.

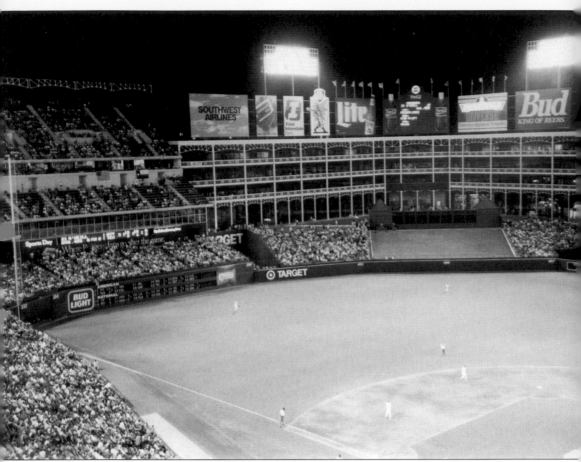

The playing surface of The Ballpark in Arlington measures 334 feet to left, 388 feet to left center, 400 feet to center, 407 feet to the deepest part of right center, and 325 feet to right. The bullpens, which are raised several feet above the field level, allow fans to see who is warming up. The fences are 14 feet high in left field and eight feet in center and right fields.

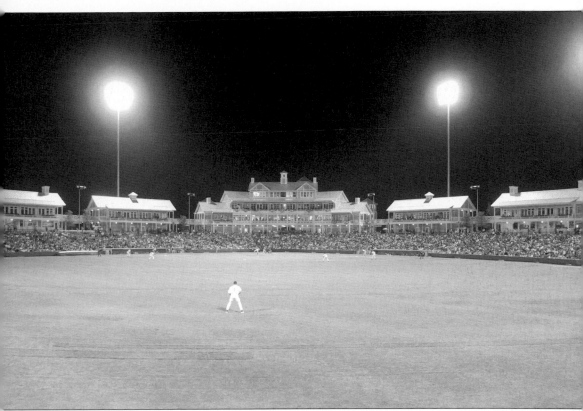

This view shows Frisco's Dr. Pepper/Seven Up Ballpark from the outfield. Owned by the City of Frisco, the facility cost $28 million, of which the city spent $22.7 million. Designed by architect David M. Schwarz and executed by Dallas architectural firm HKS, the ballpark seats 8,800 with overflow seating on the outfield berm for 1,200 more. The facility won an award from baseballparks.com as the "Best New Ballpark for 2003," beating out another Double-A park in Jacksonville, a Triple-A park in Albuquerque, and a new major league stadium in Cincinnati. (Courtesy of A. Kaye Photo/Frisco RoughRiders.)

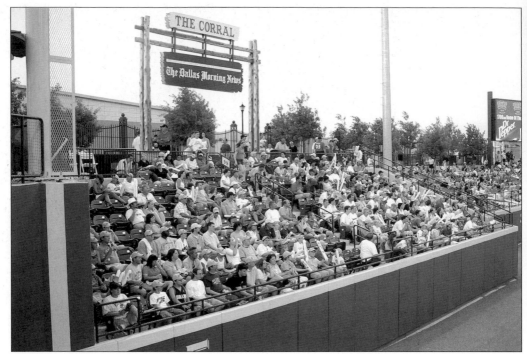

The Dallas Morning News Corral at Dr. Pepper/Seven Up Ballpark offers outfield seating for 310 fans. The outfield also features a design that allows fan to walk completely around the outside of the playing field and remain in view of the action most of the time. (Courtesy of A. Kaye Photo/Frisco RoughRiders.)

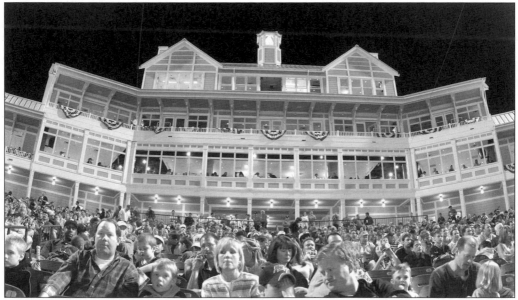

This view shows the luxury boxes at Dr. Pepper/Seven Up Ballpark. The park features 27 luxury business entertainment suites as wells as a members-only Founder's Club with a bar and full restaurant, and an L.E.D. display across the outfield wall that measures 240 feet wide by $7^{1}/_{2}$ feet tall. (Courtesy A. kaye Photo/Frisco RoughRiders.)